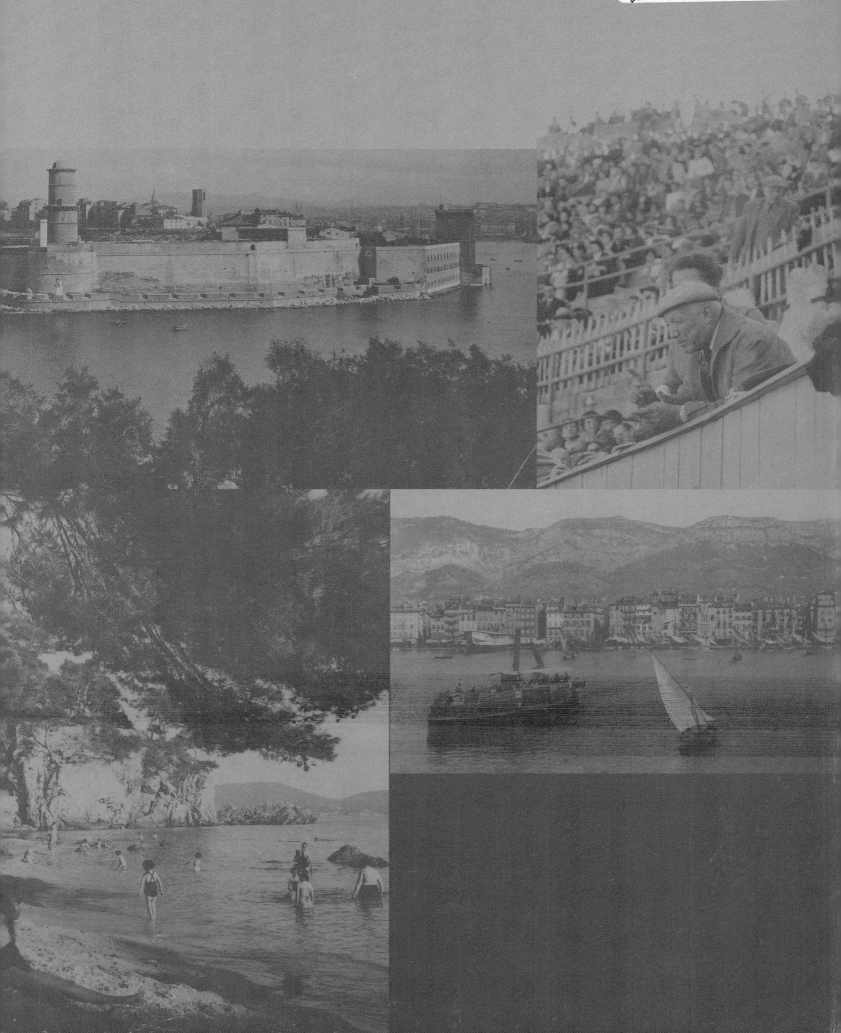

The Painters of Provence

Philippe Cros

Flammarion

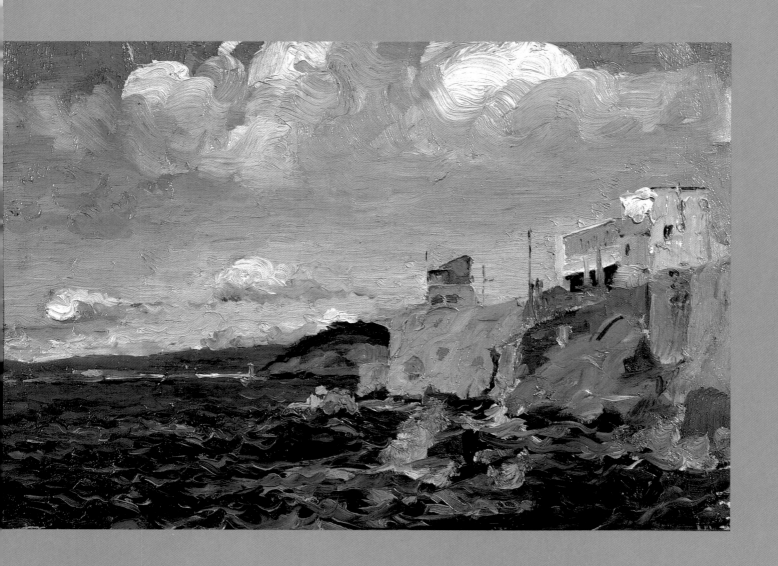

Edouard Crémieux,
La Corniche à Marseille.
Oil on panel.
Musée de la Castre, Cannes.

P rovence has for centuries been home to great artists—proudly nurturing its native sons (none of whom could stay away for long) and attracting others from not only France, but all of Europe. Irresistibly magnetic, its vast skies, verdant fields, craggy shorelines and its gentle muted light have given rise to some of the world's most important schools of art. As far back as the fourteenth and fifteenth centuries, Avignon and Nice were vibrant centers of artistic expression. At first, the Provençal countryside appeared as the background on Church-commissioned retables, but in time the allure of its unique natural beauty gave rise to a tradition of landscapes and seascapes.

By the nineteenth century, local painters such as Jean-Antoine Constantin and Émile Loubon extolled the colors of Provence, but it was undoubtedly Paul Cézanne from Aix-en-Provence who best captured the richness of the local sky and its light. After a brief stay in Paris, he never strayed far from his home town, and the region around Aix was the principal subject of his paintings.

The serenity of Provence, along with its moderate climate, drew artists seeking escape from the whirlwind of Paris, or like Pierre Auguste Renoir, relief from crippling

arthritis. But there can be no painter who benefited more from Provençal tranquility than Vincent van Gogh. Arriving in Arles in 1888 with the dream of founding an artists' colony, van Gogh completed hundreds of paintings and drawings in his two-year stay. And even during his year-long confinement in a psychiatric clinic in Saint-Rémy, he spoke of the fruit born from the "stronger light and the blue sky."

The "Coast of Modern Art" stretched from L'Estaque to Saint-Tropez and proved to be extraordinarily fertile ground for early twentieth-century painting. Artists such as Paul Signac, Raoul Dufy, Georges Braque and Pablo Picasso found refuge here, and the crucial movements of modern art—Fauvism, Impressionism, Cubism, Dadaism—all had their Provençal travelers.

In this journey through the cities and villages of Provence we explore the influence the region's natural beauty had upon individual artists and the evolution of European painting. The subtle power of its light, the dramatic juxtaposition of ancient relics and contemporary scenes, and the convergence of several cultures all come forth in the works of all these artists who were privileged to spend time in the region.

From left to right:
Francis Picabia,
André Dunoyer de Segonzac,
Moïse Kisling
and Raoul Dufy.

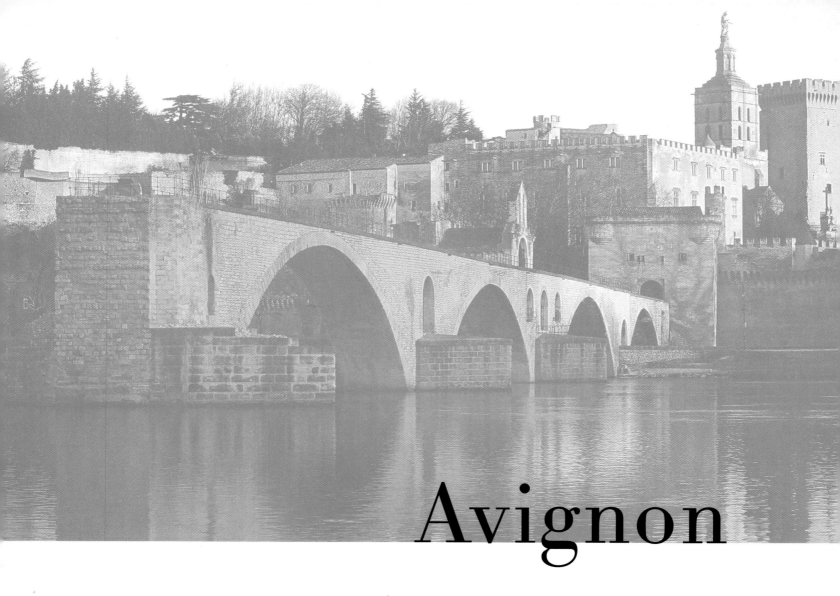

Avignon

Avignon, with its steeples, battlements and turrets that recall the imaginary cities of antique engravings, is a picture in itself. So it is not surprising that in the fourteenth century, with the exile of the papal court to the city, a group of mostly Italian painters created the Avignon School, forming one of the most brilliant artistic centers in Europe. The influence of this school stretched across Europe before falling into decline at the end of the fifteenth century. Nevertheless, the city's pictorial tradition was too strong to lay dormant for long, and in the seventeeth and eighteenth centuries Avignon once again produced dynasties of remarkable artists, including countless Parrocels, four Mignards, and no less than eight Vernets. Claude-Joseph Vernet, the great marine painter, would never forget Provence was his home, and the most beautiful of the seascapes in his *Ports of France* series (commissioned by the marquis of Marigny, who was director of the city's art school), are those of his native region. A fine example is *Pêche au thon dans la baie de Bandol* (page 8), a ceremony attended by all of high society. This type of fishing, known as "à la Madrague" in which the fish are encir-

cled by nets, has given its name to a number of small ports along the coast. The spectacle was always a great success, and the most prestigious guests left with a silver trident.

Resulting in the reunification of Avignon with France in 1791, the Revolution sounded the death knell of this richly colored period of the city's history. During the nineteenth century, under the influence of Romanticism, Avignon painters became more intrigued by landscapes than the sumptuous scenes of the past. Paul Saïn pursued the classical landscape tradition, and his seductive *Panorama matinal sur le Rhône* explains the respect the artist received in Paris. Five centuries after the height of the Avignon School, he returned to the superb landscape pictured on the Pérussis altarpiece which now hangs in the Metropolitan Museum of Art in New York. Saïn's intention, however, was not to give a detailed description of the city. Viewed from the east rather than the north, Avignon becomes the pretext for a colorful spectacle, with Saïn rejoicing in hazy effects and subtle tones. The pride the artist held for his town can be sensed in the graceful silhouette of the city. How could artists working here fail to have a strong regional identity for this unique site,

Opposite: the Bénezet bridge in Avignon.

———

Paul Signac, *Le château des papes à Avignon.* 1900. Oil on canvas. Musée d'Orsay, Paris.

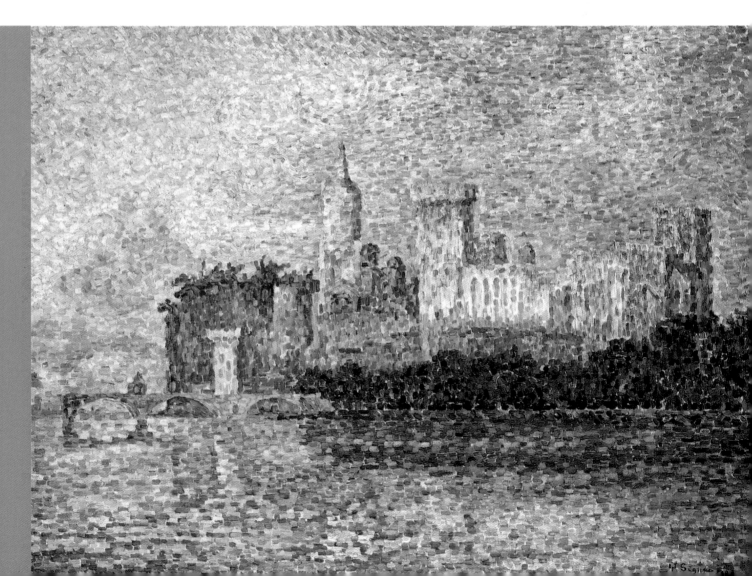

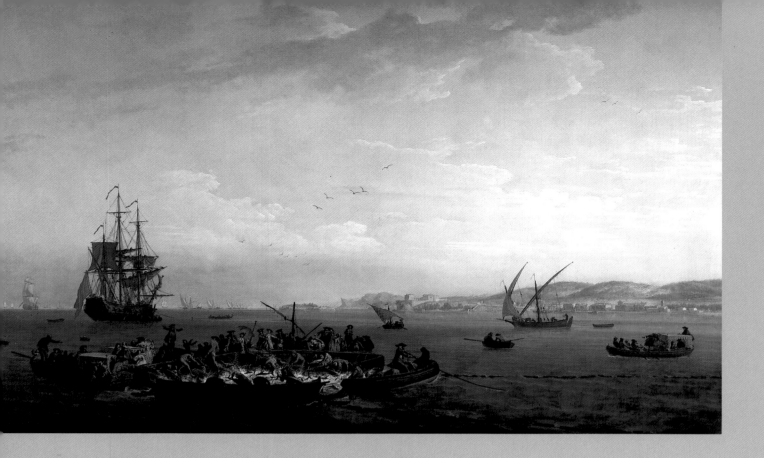

Claude-Joseph Vernet, *Pêche au thon dans la baie de Bandol.* 1755. Oil on canvas. Musée de la Marine, Paris.

where the papal city scornfully eyed the fortresses of the king of France?

By the nineteenth century, Villeneuve-lès-Avignon was no longer home to the main residences of cardinals who had fled from the crowded urban center, but it did conserve the historical monuments that were sure to attract a painter's attention. Despite settling in Paris to further his career, Paul Saïn found the means to teach his fellow townsman Louis Montagné. Montagné was to become a notary public, but fate deemed otherwise, and despite comfortably settling in Paris like Saïn, he kept close ties with his native city and efficiently reorganized its art school. His *Fort Saint-André et la plaine de Villeneuve-lès-Avignon au soleil couchant,* successfully presented at the 1907 Salon, is a remakably profound painting which displays all the poetic tenderness and sensitivity of Montagné's master.

The sense of a regional identity that we have already seen gave birth, in 1854, to the literary movement "Félibrige," which promoted use of the Provençal language and was dominated by the reputation of the poet Frédéric Mistral (who would go on to receive the 1904 Nobel Prize for literature.) It also touched the world of painting. The Avignon school of fine arts played a unifying role in this domain and, by offering a classical education, forged a regional school that took malicious pleasure in setting itself apart from the Marseilles School, which was more inclined toward modernity and practiced painting in "full sunlight."

A student of Grivolas, director of the Avignon School of

fine arts, Clément Brun would always retain the levelheaded spirit of the school's teachings, which seem to have been oblivious to the conquests of Impressionism. In fact, even though he performed major functions at the Académie Julian where the Nabis first came together, Brun seems to have paid no attention to that short-lived but gripping movement. Even better, his rather sober *Rue de l'église, Villeneuve-lès-Avignon* was painted at the height of the Fauve period, and yet not the slightest influence of this powerful new trend seems discernable in his temperate work. It matters little: the painting received an excellent reception at the Salon where it was praised for its fine composition reinforced by the striking division of darkness and light. Along with a precise depiction of the street, the canvas also presents a faithful image of a past that is recent and yet long gone, embodied in the religious procession passing under the protective shadow of the church tower that blocks the background of the composition.

In addition to the local painters—who in spite of their undoubted talent never embraced modern trends—giants of modern painting passed through Avignon transcribing the age-old image of the papal city into twentieth-century style. In his *Le château des papes à Avignon* (page 7), Paul Signac perfectly captures the enchanting beauty of Avignon in the setting sun, as seen from the far bank of the Rhone. The tones of the sky and the papal palace merge, and the vertical brushstrokes of the walls of the old building serve to accentuate its verticality. In 1884, Signac was one of the founding members of the Société des Artistes Indépendants and it was at this time that he met the painter Georges Seurat. This was a decisive meeting; it was thanks to Seurat that the two artists became the principal developers of Divisionism. With Divisionism began a determined return to drawing and a systematic approach to the "reality" discovered by Impressionism. Initially Signac showed great interest in the scientific analysis of the simultaneous contrast of colors, but later, the systematization of brushstrokes gave way to more exclusively aesthetic preoccupations, as can be seen in this painting.

Other innovative painters took a detour through the ancient city in the footsteps of Signac. To execute his *Vue d'Avignon et du fort Saint-André* (overleaf), André Lhote placed himself further back than Montagné's view, whose slopes sheltered from the mistral winds and the valley's morning fog had in the meantime been built up with villas. This angle allowed Lhote to depict both Villeneuve and, in the background, the immutable outline of Avignon, all in a highly structured composition using a restricted range of colors.

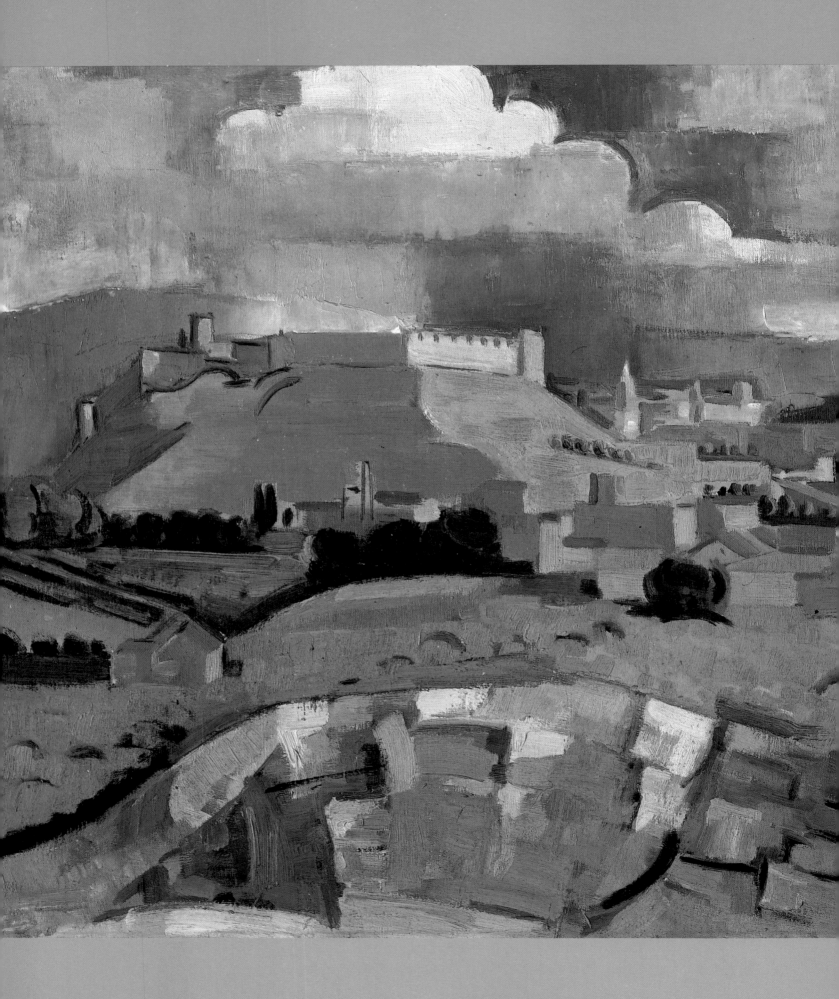

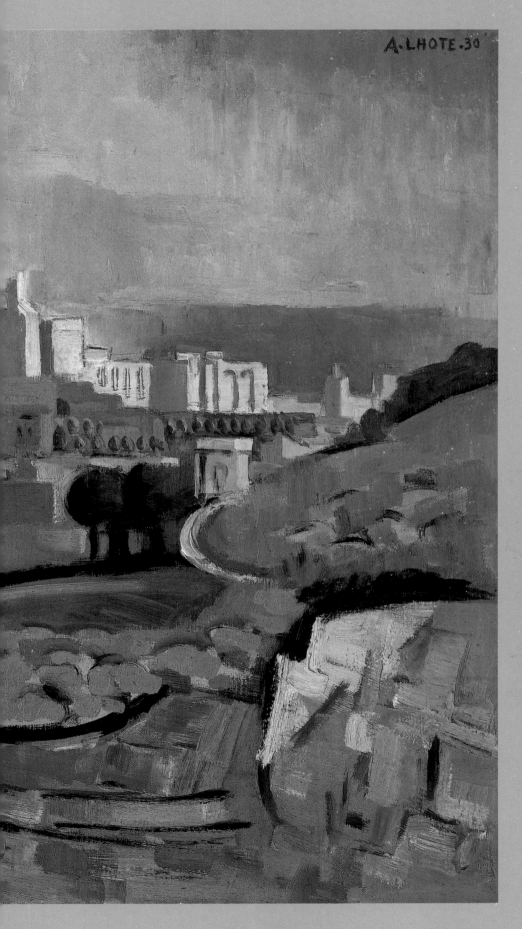

André Lhote,
Vue d'Avignon et du fort Saint-André.
1930. Oil on canvas.
Musée national d'Art Moderne, Paris.

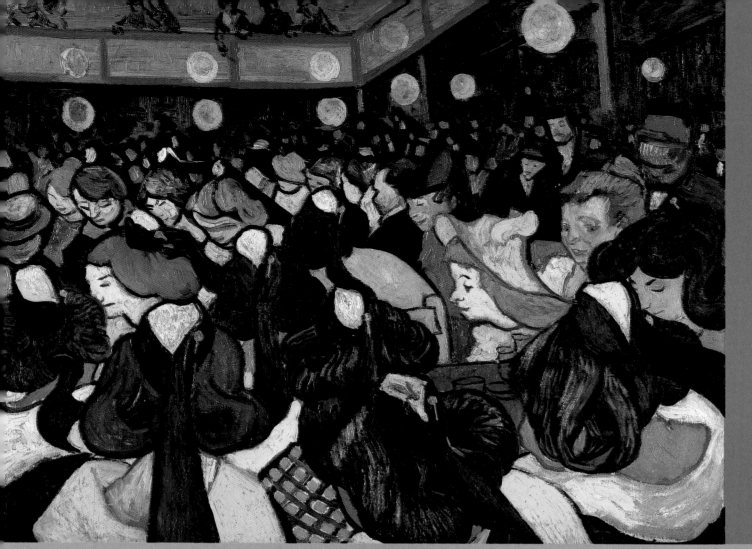

From Arles to Saint-Rémy

Arles

Saint-Rémy-de-Provence

Arles

In the Summer Garden of Arles, near the remains of the exterior portico of the Roman theater, the stroller can muse over the fruits of genius and madness before the bust of Vincent van Gogh, who arrived in the city in February 1888 with the dream of setting up an artists' colony. Following the disappointment of Gauguin's less than enthusiastic visit, van Gogh painted passionately between recurrent hospital stays until he was finally admitted to the asylum of Saint-Rémy-de-Provence. Arles played a domi-nant role in the painter's destiny and some of the sites he painted can still be found intact. The Langlois Bridge, for example, which has since been moved, is known in Arles as the "van Gogh Bridge." During the fifteen months that he spent in Arles, van Gogh completed no less than two hun-dred paintings and one hundred drawings. Although the town, alas, owns none of his works, the Van Gogh Café once again looks as it did in *The Night Café*. *The Dance Hall at Arles* provides an accurate representation of this magical period during which, in order to do justice to the beautiful light of Arles, van Gogh evolved toward a brighter palette. But, sadly for van Gogh, the discovery of

Opposite: Vincent van Gogh,
Dance Hall at Arles. 1888.
Oil on canvas.
Musée d'Orsay, Paris.

———

Picasso in the Arles
Amphitheater.

light did not mean the end of the darkness where his demons irresistibly drew him. Even if Gauguin, at the same time that he adopted his Symbolist theories, shared with van Gogh his dream of a utopian artists' community, he only came to visit the latter in Arles reluctantly—he happened to be under contract with Vincent's brother, Theo van Gogh. At the time, Gauguin was obsessed with faraway destinations and it was only later that he recognized the positive aspects of his stay in Arles, even going as far as to say that it was on this occasion that he had taught Vincent "the orchestration of a pure tone by all the derivatives of that tone." Even if this opinion is an overstatement and displeased van Gogh, we should make note of the presence of pure red and its derivatives through a range of oranges in Gauguin's beautiful landscape *Les Alyscamps*—a technique van Gogh and the Fauves would later use to great advantage. Although Gauguin was soon disappointed in life with van Gogh, his stay in Arles did produce this fine landscape, with its great attention to classicism, balance and harmony. Celebrated as it was, the site could not fail to interest Gauguin, who was so taken with spirituality. For fifteen hundred years, Les Alyscamps was the necropolis that residents from the banks of the Rhone chose as their final resting place. At first it was said that, in 1152, the body of Saint Trophime was brought from Saint Honorat and reburied at Les Alyscamps. Then, over the centuries, it was added that Christ had appeared during the burial. It then became difficult to resist including the graves of the heroes fallen at Roncevaux, from the medieval epic poem *Le Chanson de Roland*. These rumors made the place so popular for burials that residents of the Rhone basin entrusted their coffins to the river in the hope that they would be carried down to Les Alyscamps. The coffins, each containing an offering, were stopped by the Trinquetaille Bridge, famously painted by van Gogh—an unconscious premonition for an artist who had so little time left to live.

By an easily forgiven imbalance, van Gogh seems to have outshone all other Arlesian painters, but in a proud act, Arles has nonetheless given the name of Jacques Réattu to a museum—housed in a fourteenth-century building constructed by the Knights of the Order of Malta—that holds the major part of this local artist's work. A painter of historical scenes in the strict tradition of the Académie, Réattu would have found it hard to imagine that, only a century later, the painters of Provence would consider the observation of light and color a pictorial end in itself. And

Paul Gauguin,
Les Alyscamps, Arles.
1888. Oil on canvas.
Musée d'Orsay, Paris.

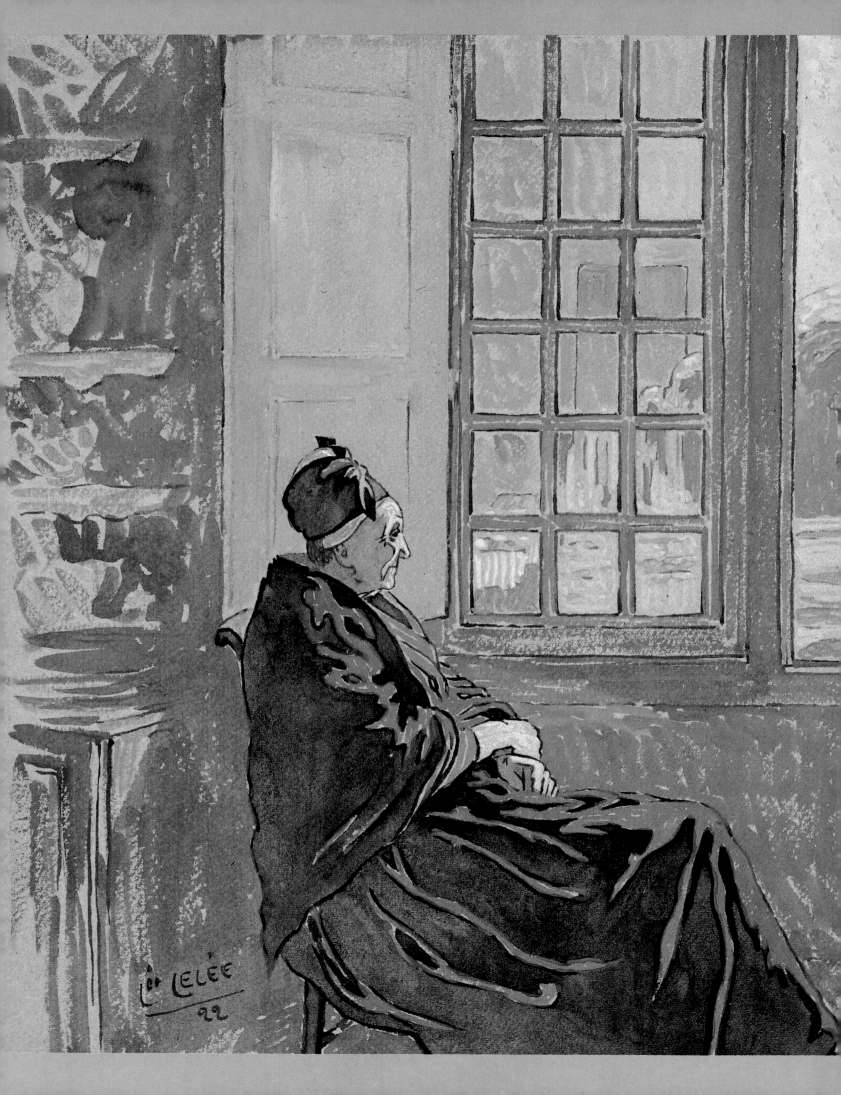

"I am in Arles feeling completely out of place, so much do the countryside and small-minded folk here displease me. Vincent (van Gogh) and I are not getting along at all in general, but especially when it comes to painting. He admires Daumier, Daubigny, Ziem, and the great Rousseau, all people I cannot stand. In contrast, he hates Ingres, Raphael, Degas, all people I admire; I tell him, brigadier, you're right, just to have some peace. He loves my paintings, but when I work he always tells me that I am doing something or other wrong. He is a romantic and I am more inclined to the primitive state. Regarding color, he sees the unpredictable nature of the palette, like Monticelli, whereas I hate the contrived manipulations of the brushstroke [...]"
Letter from Gauguin to
Émile Bernard, December 1888

Léo Lelée, *Grand-mère devant les arènes d'Arles*. 1922.
Gouache watercolor.
Musée du Vieil Avignon, Avignon.

how would he have perceived the drawings by Picasso which now hang alongside his own works painted during the French Revolution? The extraordinary diversity of style, technique and materials of Picasso's numerous drawings from late in the artist's life, often sketched on the front and back of a single sheet, clearly show the genius of an artist unconcerned with growing old. Picasso loved Arles and came here regularly to attend the bullfights. When the museum curator visited the painter at Mougins in order to organize an exhibition, Picasso presented him with nearly sixty such works.

Next to these giants of modern painting who passed through Arles, and those like Réattu who dreamed of a broader recognition than that received from the local bourgeoisie, many more obscure but no less engaging painters set up their easels in order to capture the city's unique panoramas composed of a blend of Antique remains and fine classical architecture. There is much tenderness in *Grand-mère devant les arènes d'Arles* (preceding page) by Léo Lelée. Given his beautiful rendering of the Arlesian light, it might be assumed that Lelée was from the region, but this was not the case. A native of Anjou and a renowned ornamenter in Paris, he traveled through Arles and, falling in love with the countryside, became involved with the members of the Félibrige group. Married to a woman from Arles, he became – thanks to the friendship of Mistral – the official illustrator of the Félibrige and Camargue festivals. Contrary to what one might expect, depictions of the amphitheater are surprisingly rare in local iconography. This is probably due to the fact that it is difficult to find an angle that is of artistic and not simply architectural interest. Lelée's composition is original with its added emotive dimension in the touching figure of the elderly woman contemplating the backdrop to her long life. The light itself is treated with considerable talent: a few brushstrokes of orange evoke the outside light, while cool tones convey the half-light of the room. The scene is painted from Lelée's own home and it is still possible to stand before the window, which appears in the center of the composition, and admire an unchanged view bathed in the same light.

Vincent van Gogh,
La Chambre de Van Gogh à Arles.
1889. Oil on canvas.
Musée d'Orsay, Paris.

Saint-Rémy-de-Provence

Arles and Saint-Rémy—there is not an art lover for whom the names of these two towns are not tragically linked. Near Saint-Rémy, there is a building that has been known since 1117 as the monastery of Saint-Paul-de-Mausole. Today, a neuropsychiatric clinic hides behind its handsome eighteenth-century façade. It is best known for having van Gogh as a patient during the year 1889–90, sent by his doctor in Arles who was only too happy to be rid of him. The time spent in the asylum was a relief for the artist, freeing him of the daily worries of providing for himself. He even said in a letter to Theo "my fear of madness is wearing off markedly, since I can see at close quarters those who are affected by it in the same way as I may very easily be in the future."[1] However, between his bouts of delusion, he remained the great genius esteemed by posterity, painting such powerful works as *L'asile Saint-Paul à Saint-Rémy*. During much of his confinement, he was allowed to paint in the surrounding countryside, and in a letter to Theo in which he says "my mind is working in an orderly way," Vincent remains optimistic even from within his asylum room. "Still, perhaps my journey to the south will yet bear fruit, for the stronger light and the blue sky teaches you to see, especially or even only, if you see it for a long time."[2] After this illustrious and tragic patronage, Saint-Rémy could not help but attract painters, even if none of them would have the extraordinary reputation of van Gogh.

Another draw of Saint-Rémy lies in the memory of Maro Prassinos who, while spending part of each year there, created the magnificent and touching testament, *Peintures du Supplice,* for the chapel of Notre-Dame-de-Pitié.

Opposite: Vincent van Gogh,
L'asile Saint-Paul à Saint-Rémy.
1889. Oil on canvas.
Musée d'Orsay, Paris.

———

Vincent van Gogh,
Self-portrait.
1889. Oil on canvas.
Musée d'Orsay, Paris.

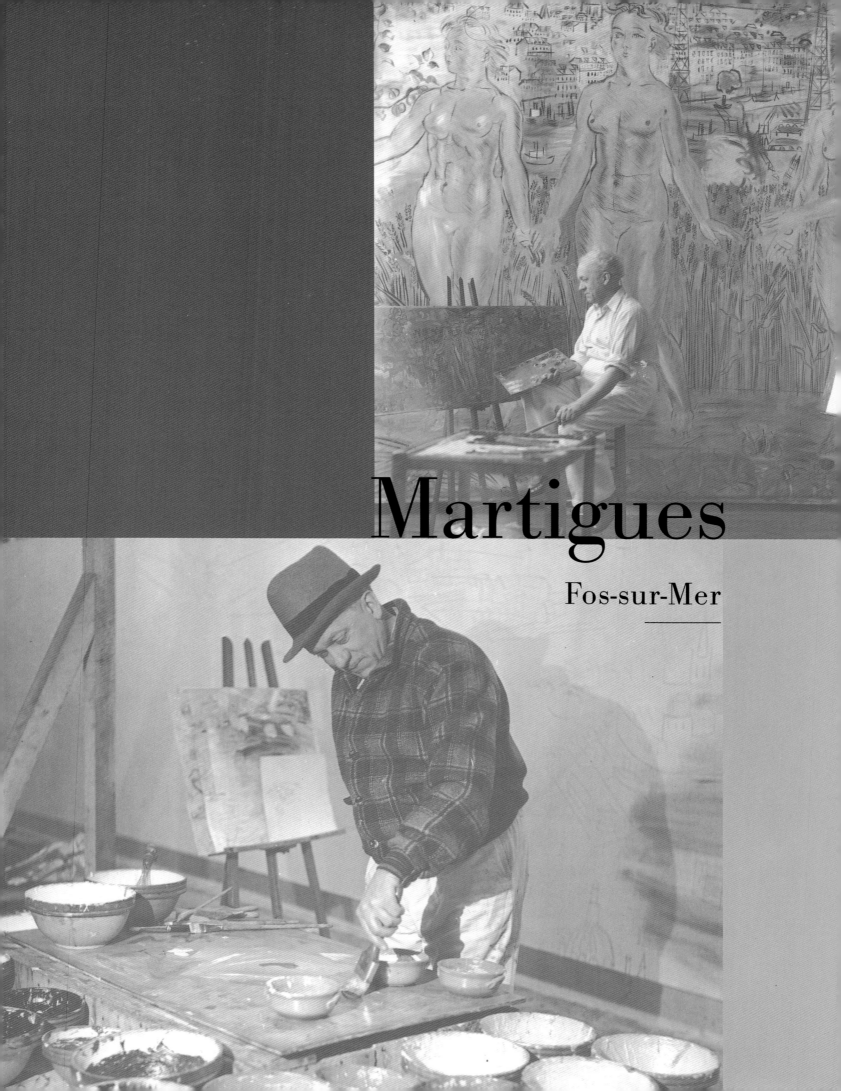

Martigues

Fos-sur-Mer

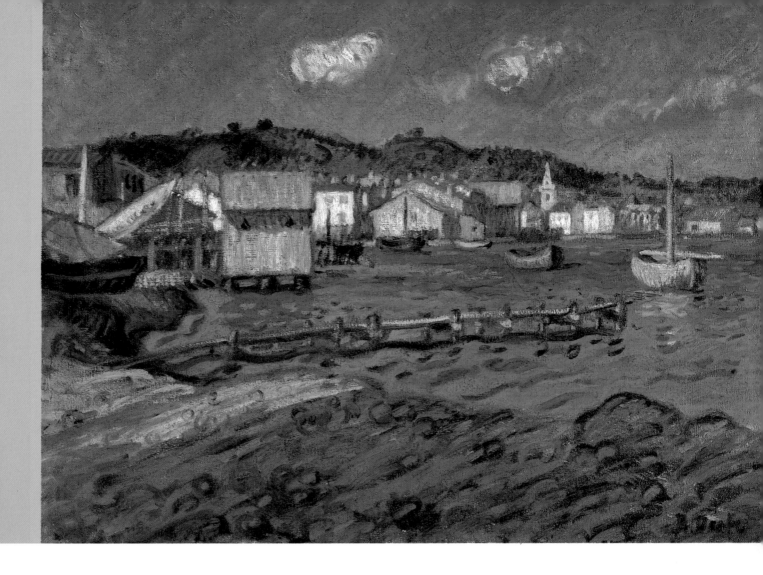

With its expansive skies, canals and noble façades, Martigues could be a principality in miniature, if the seductive and sometimes misleading landscapes painted by such artists as Félix Ziem, who were enchanted with this town, were taken as proof. In 1884, Émile Loubon produced his fine *Panorama de la ville et du port de Martigues* (overleaf). Not exactly a marine scene, this genre is rare in the work of Loubon. The painting was, in fact, commissioned a year earlier by the Minister of the Interior. Its large size and use of two contrasting planes—one in bright light, the other in theatrical chiaroscuro—make it difficult to ignore Loubon's deference to the classical tradition. This faithfulness to the past, however, in no way diminishes the importance of Loubon, who, as director of the Marseilles art school, was able early on to put Provençal painters in touch with their Parisian contemporaries. While the historical town center has remained unchanged and the neighborhoods in the painting are still crossed by the canals that gave Martigues the name of "Provençal Venice," the industrial growth of the last quarter century has tainted Loubon's countryside and chased away the colorful fishing

Opposite: Raoul Dufy in his studio.

———

Raoul Dufy,
Le Port de Martigues. 1904.
Musée Cantini, Marseilles.

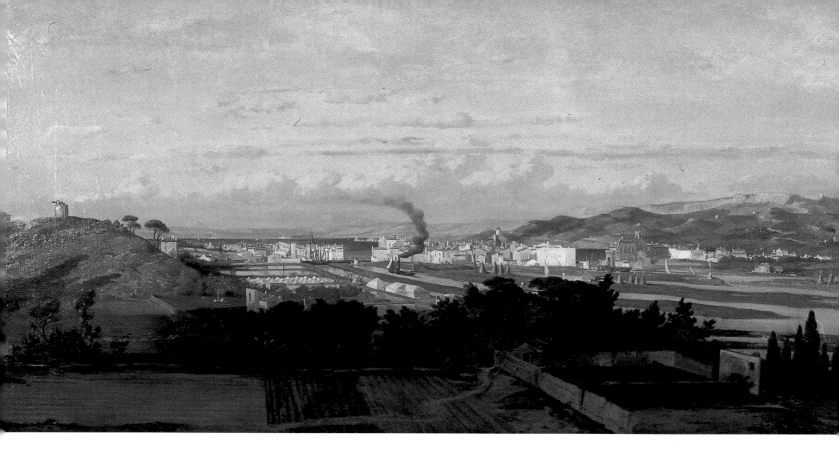

Emile Loubon,
*Panorama de la ville
et du port de Martigues.*
1844. Oil on canvas.
Collection of the Chambre
de commerce et d'industrie de
Marseille.

———

Opposite: Félix Ziem,
Tartanes.
Musée Ziem, Martigues.

boats. But for those nostalgic for a pre-industrial past, the painting, along with these words of Charles Maurras, remain: "The prime beauty of Martigues is the Berre Lagoon, that the morning whitens and the evening makes blue… The lagoon, with its green tongues, lovingly licks the inlet's sand and gnaws at rocks where people fish for mullet."[3]

The scene is set. Situated at the edge of the Berre Lagoon and traversed by canals, "Provençal Venice" could not fail to seduce the Orientalist painter Félix Ziem who was fascinated by the glistening reflection of façades in the water and the brightly colored fishing boats. Born in Burgundy, this inveterate voyager found in Martigues the romanticism of Venice. *Tartanes* is a magnificent example of the deeply poetic work of this artist. Ziem set up his studio and a museum on the edge of the Caronte Canal, which flows into the sea. Today, the Musée Ziem is located in a nineteenth-century customs house. Along with the 680 paintings, 1,200 drawings and the engravings that come from the studio's collection, the museum also includes a room devoted to reconstruction of the artist's various studios. This staging would not have displeased Ziem, who in order to recreate the ambiance of the banks of the Bosporus, built replicas of minarets along the Caronte Canal, on the axis of the setting sun.

In a style somewhat influenced by Impressionism, Charles Pellegrin painted *Petit Port de Martigues* (page 28), depicting the "Miroir aux Oiseaux," the name given to the Brescon Canal located in the island neighborhood. In true

Venetian style, the foundations of the façades plunge into the water. The drawbridge in use today did not exist in Pellegrin's time, but the quai Brescon that can be seen here is still cluttered with small boats, and the *hôtels particuliers* inspired by the fine architecture of Aix still display their ocher façades. Although the lateen sails have been replaced by more modern rigging, painters continue to come every summer to capture the canal's magical light.

Yet another painter more illustrious than Pellegrin, and even than Ziem, succumbed to the charms of Martigues. Raoul Dufy's *Le Port de Martigues* (page 23) pays tribute to Impressionism, both in its spirit as well as in its construction and its subtle rendering of atmosphere. At the same time, this work already reveals the beginnings of an intense freedom that would result in the magnificently vivid contrasts of Dufy's canvases painted in 1906. In his other seascapes, such as *Les Martigues* (overleaf), the composition always presents a stretch of water in the foreground and a deliberately high horizon. Unfortunately, since 1903 the neighborhoods of L'Isle and Jonquières depicted here have undergone great changes, and both Brescon Point and the bridge have been destroyed. The Church of Saint-Geniès, however, remains as it was, and it is hard to imagine from this peaceful image that the three neighborhoods separated by canals were once rival cities.

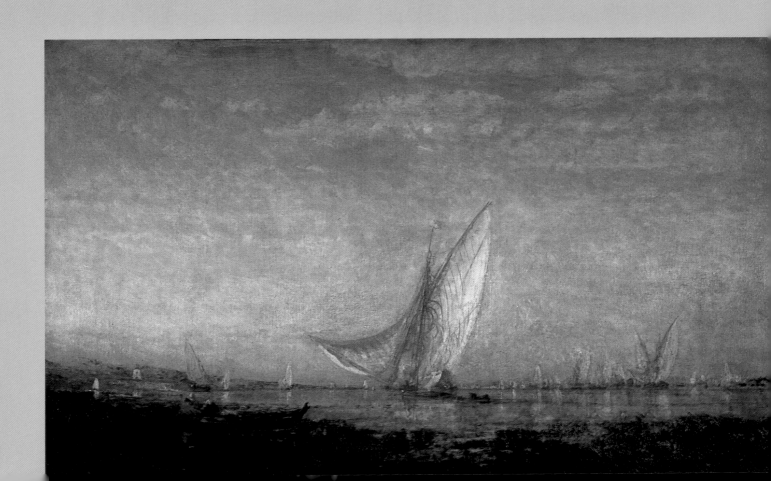

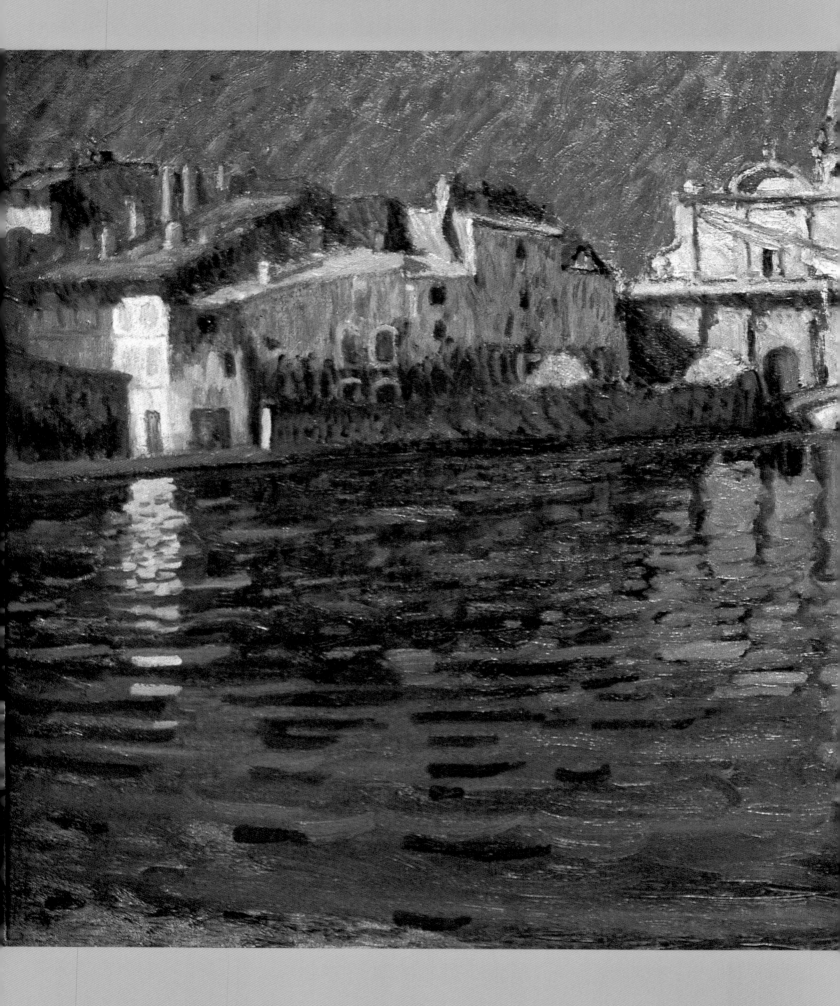

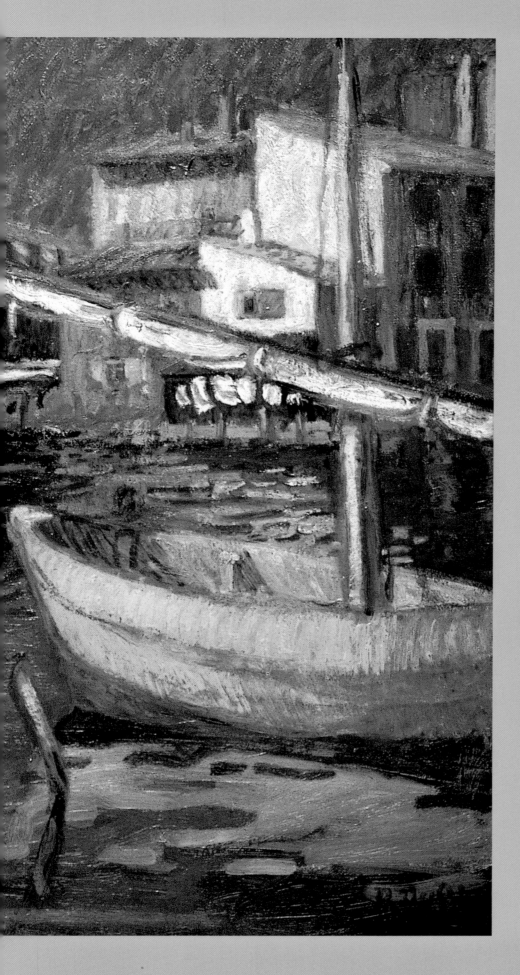

"Is there a limit to the desire of free expression in time and space [...] In the sea, I would like to rediscover the ancient myths of which I still feel the vital presence. The idea, the taste, the feeling of the sea that gave birth to Amphitrite have not changed at all [...]. There is but one mythology, I feel that it is young and alive in the unchanged nature of things and the men that express it, and I can no longer see a landscape without trying to feel, within it, the passage of time."
Raoul Dufy

Raoul Dufy,
Les Martigues.
1903. Oil on canvas.
Musée Ziem, Martigues.

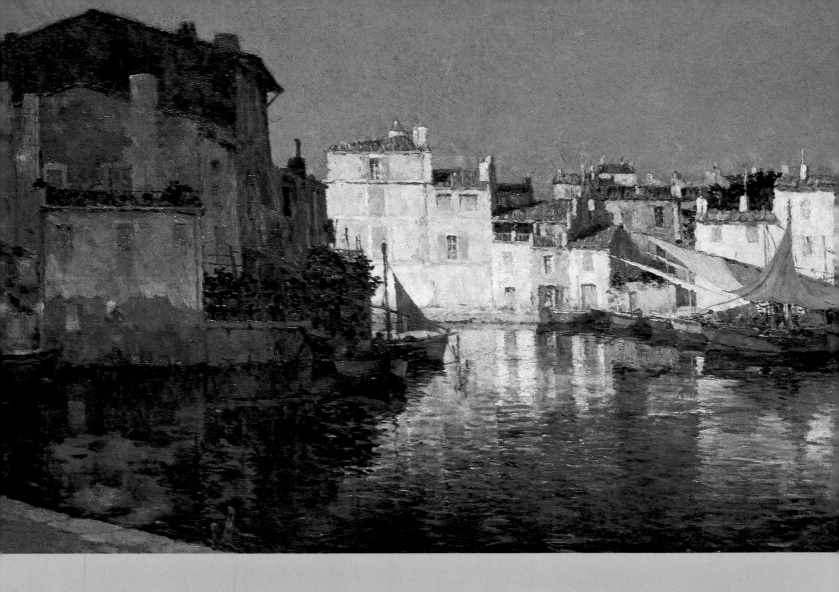

Fos-sur-Mer

Fortunately, quite a few painters turned to the pretty countryside of Fos-sur-Mer before the modern world left its mark, and in Joseph Garibaldi, Fos found a very perceptive artist. Along with this small town, Garibaldi painted the major quays and ports between Marseilles and Toulon, as well as numerous historical monuments of Provence. His works were enthusiastically collected by the baron de Rothschild. Such flattering patronage could only encourage the critics to shower Garibaldi with acclaim, and this they duly did, endlessly praising the minute and picturesque detail of the artist's compositions. Yet, despite his undeniable strength for composing a scene, Garibaldi could never match the brilliance and talent of an artist like Jean-Baptiste Olive, and although his paintings are luminous, he would always emphasize drawing over color. Nevertheless, in this style, *Vue de Fos-sur-Mer* is a fine topographical depiction of the town, perched on its rocky spur like a ship marooned in the middle of a sandy swamp. This is the true subject of the painting, more so than the

scattered silhouettes which liven up the composition. Standing before such a picture—which Garibaldi donated to the Musée Ziem when it was founded—it is possible to forget the huge industrial harbor complex that appeared at the end of the 1960s, and remember instead that Fos is one of the oldest sites of Provence. In addition to its fine composition, this painting is also remarkable for its treatment of light, both in the very formal division of foreground between a dark and very brightly lit area, and in the strange whiteness of the sky. Urban sprawl has somewhat disrupted this landscape, but the church of L'Hauture still dominates the mound on which the population took refuge in the Middle Ages and where the old town of Fos was founded.

Opposite: Charles Pellegrin,
Petit Port de Martigues.
1905. Oil on canvas.
Musée de la Castre, Cannes.

———

Joseph Garibaldi,
Vue de Fos-sur-Mer.
Musée Ziem, Martigues.

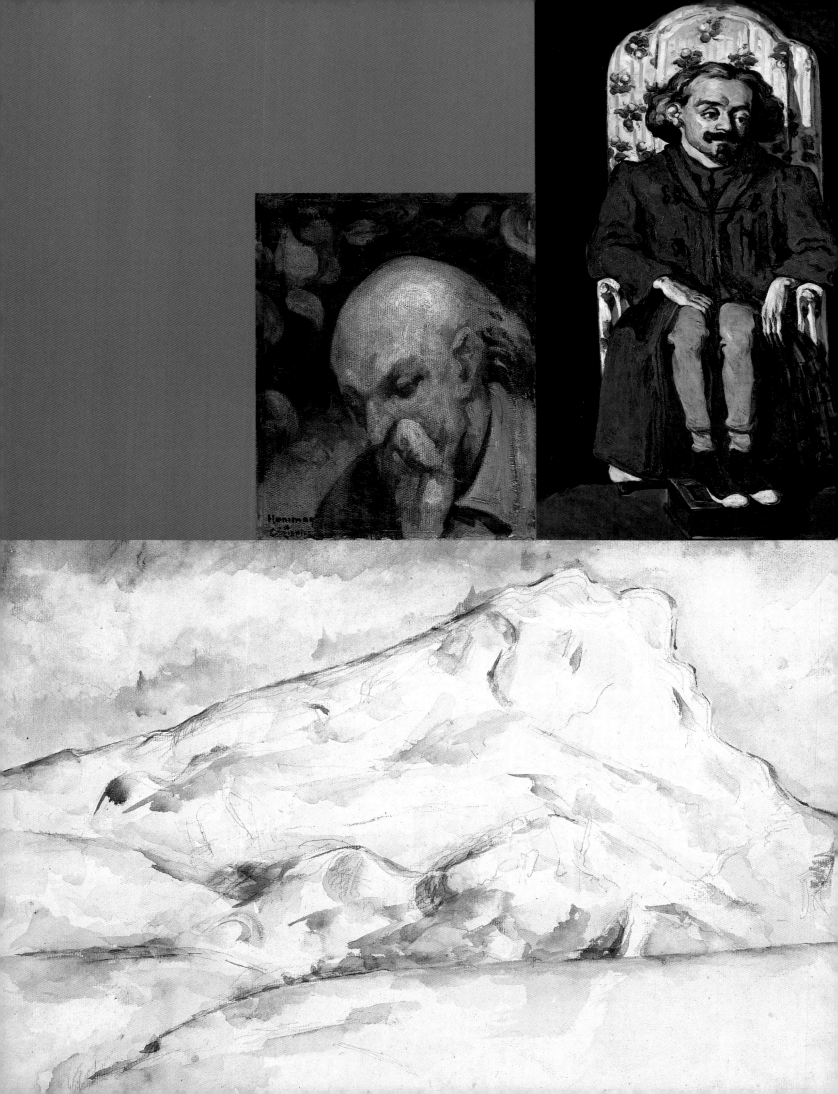

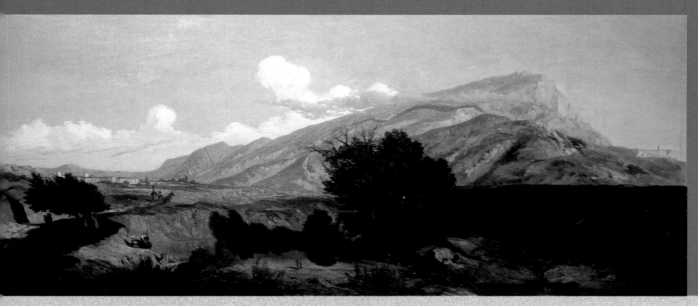

Aix and its surroundings

Aix-en-Provence
——————

Vauvenargues
——————

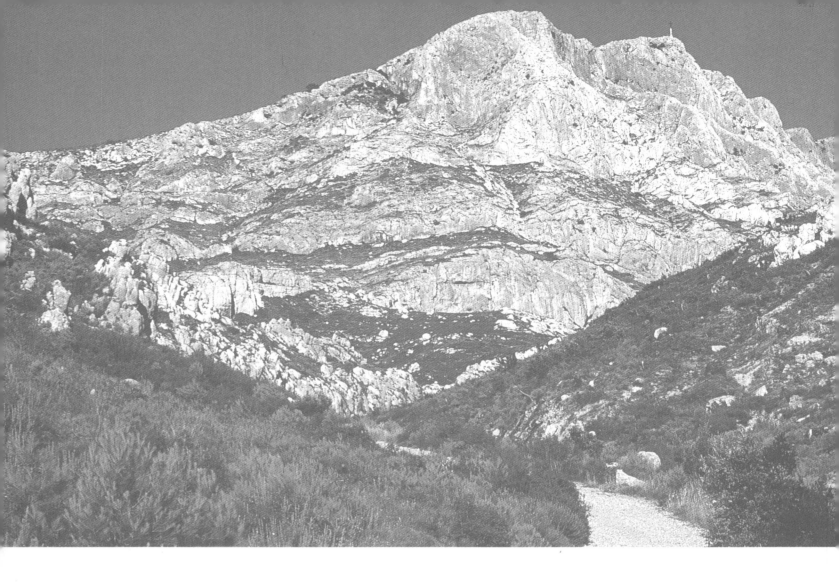

Aix-en-Provence

Preceding pages, top left:
Émile Bernard,
Portrait of Cézanne. 1904.
Musée Granet, Aix-en-Provence.
Top center: Paul Cézanne,
Portrait of Achille Empéraire.
1869–70. Oil on canvas.
Musée d'Orsay, Paris.
Top right: Prosper Grésy,
*La Montagne Sainte-Victoire
et le hameau des Bonfillons.*
Oil on wood. c. 1840.
Musée Granet, Aix-en-Provence.
Bottom left: Paul Cézanne,
La Montagne Sainte-Victoire.
1900–2. Oil on canvas.
Musée d'Orsay, Paris.
Bottom right:
Photograph of the Mont
Sainte-Victoire.

With its harsh rocky relief and intense light, Aix was destined to become a center for nineteenth-century landscape painters in Provence. Since the age of the Enlightenment, the drawing school—established in a priory of the Knights of the Order of Malta under the Restoration—offered highly academic, if somewhat antiquated instruction that ignored landscape painting. But once they had finished their studies at the fine arts school in Paris, and had passed through the studios of the official masters, local artists returned home and took revenge by celebrating the beauty of Aix and its countryside. Not only did the old parliamentary city boast numerous cafés where artists and art-lovers would meet and argue the polemics of the day, there were also groups and associations of artists that came together to debate the burning topic of modern art. In fact, by the last quarter of the nineteenth century, the majority of Aixois painters had turned their backs on Academicism in favor of an individual style that went so far as to celebrate the Provençal landscape. Obviously,

Cézanne was the major reference for many of these artists, but it would be a mistake to presume that this point of view was unanimous. For a long time, his genius was a matter of debate within the art world of Aix. As for the quirky character of the provincial Cézanne who was ill at ease in Parisian cafés, one quote suffices. In an exchange with Manet at the Café Guerbois, he excused himself, "I won't shake hands, M. Manet, I haven't washed for a week."[4]

The father of the modern school of Provence was Jean-Antoine Constantin, named in 1787 as director of the drawing school of Aix. His charming and sentimental landscapes, such as *Sainte-Victoire vue du quartier Beaufort* (page 40), show the degree to which he was a precursor of modern landscape painters. Such works would influence his student François-Marius Granet, who bequeathed his fortune and collections to the superb museum that now bears his name. Granet studied under David in Paris and lived for eighteen years in Italy, where he executed some of the background landscapes for the paintings of Ingres. After his stay in Rome, he started a trend for "Italian peasantry." He also became a specialist of romantic cloisters, and his fine draw-

Opposite: The Mont Sainte-Victoire.
––––
François-Marius Granet,
Sainte-Victoire vue d'une cour de ferme.
Oil on canvas.
Musée Granet, Aix-en-Provence .

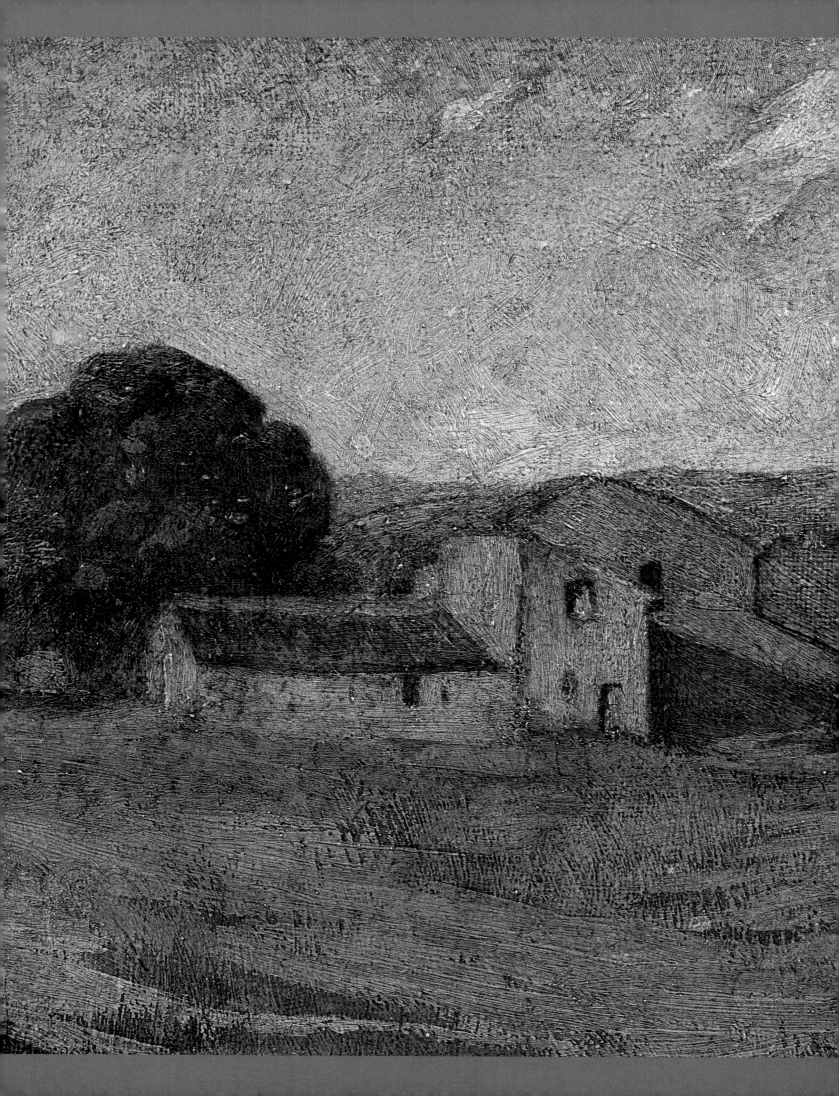

Achille Empéraire,
Paysage de la campagne d'Aix.
Oil on canvas. Musée Granet,
Aix-en-Provence.

ings prefigured the work of Cézanne. One of his most beautiful works, and a herald to Cézanne, is his *Sainte-Victoire vue d'une cour de ferme* (page 33), in which the mountain is seen from a farmyard.

So, Cézanne was neither the first nor the only artist to paint the Montagne Sainte-Victoire—far from it. Both in literature and in local folklore, the mountain was endowed with legends each more exalting than the last. While the Montagne Sainte-Victoire was in fact named in memory of the Christian victory over the Turks at the Battle of Lepanto in 1571, romantic imaginations were quick to switch the dedication to the Roman general Marius, vanquor of the barbaric Cimbri. Sir Walter Scott pursued this same theme in his novel *Anne of Geierstein*. Yet, perhaps the true reason the mountain kept the name of Sainte-Victoire is far less grandiose. In 1653, Honoré Lambert, an ailing shopkeeper from Aix, made a vow to restore the chapel known to locals as Mont Venture and to dedicate it to Notre-Dame-de-Victoire.

Notwithstanding this history woven in legends, we know that as early as the sixteenth century local painters

Opposite: Émile Bernard,
Paul Cézanne painting in his studio.
Silver gelatin print on paper.
Musée d'Orsay, Paris.

———

Photograph of Cézanne's studio in Aix-en-Provence.

paid homage to the mountain, since Saint-Victoire is prominently depicted on the retable of the Aix parliament, housed in the Church of the Saint-Esprit. Highly symbolic in the work of Cézanne and other lesser-known artists, the image of Sainte-Victoire in the eyes of Aixois painters remains a melding of childhood memories and the retold tale of the battle of Marius against the Teutons in 102 B.C.

Younger than Constantin and Granet, Prosper Grésy was nevertheless considered by some to be the pioneer of Provençal landscape painting, even before Émile Loubon. The innovative format of *La Montagne Sainte-Victoire et le hameau des Bonfillons* (page 31) with its grand panorama allows the mountain to be presented in all its majesty. To capture both the mountain and the hamlet, the painter set up his easel on the slope of a hill at the Château de Saint-Marc-Jaumegarde. Today, the mountain is no longer visible from this vantage point, now covered by a pine forest.

The artist Barthélemy Niollon (1849–1927) was also enthralled with the "inspired mountain" that had such a profound effect on Cézanne. Yet nothing predisposed Niollon to become a painter. After escaping death from a mining explosion at the age of thirteen and then working as a candy maker, it was not until the age of forty-five that he devoted himself to painting. His life came to an untimely end when he fell from the roof of his studio. Niollon never left Aix and the love he held for the scenery of his native countryside limited his artistic creations to a few themes, including the Montagne Sainte-Victoire.

Often considered a true "inventor" of modern art, Paul Cézanne was, of course, the cornerstone of Aixois artists. A classmate of Zola, Cézanne knew the serenity of Aix before being swept up in the whirlwind of Paris, but he never stayed away from his home town long. In 1897, he had a modest house built to the north of the old town where he set up his studio. Today, the visitor can stand at the studio window and view the Montagne Sainte-Victoire. Here, in contrast with the fleeting brilliance of Impressionism, Cézanne presented an art that was solid and structural. As of 1885, he frequently painted the scene before him, rendering with admirable acuity the green and ocher rhythm of the pine trees and the land, the vibrant atmosphere and the crystal-blue tinted vegetation. Cézanne preferred to work undisturbed and planted his easel far from the road so as to discourage any possible intruders. Today, in addition to Sainte-Victoire, the visitor can discover other nearby sites immortalized by the painter. Among these are his family estate of Jas de Bouffan, the villages of L'Estaque

Joseph Ravaisou,
Château Noir.
Musée Granet, Aix-en-Provence.

and Gardanne and the site of the Château Noir, magnificently depicted in *Rochers près des grottes au dessus de Château Noir*. The studio at Cézanne's home in Aix was saved from destruction in 1954 by an American association, and now houses a number of the painter's personal items, including his easel and country clothing, as well as the everyday objects from his still lifes—pitchers, bottles and an array of Provençal pottery. The collection is as humble as it is moving.

Another Aixois, Achille Empéraire, a misshapen and sad-looking dwarf whose destiny and talent call to mind Toulouse-Lautrec, is known to posterity thanks to the harsh portrait of him done by his friend Cézanne. In *Portrait d'Achille Empéraire* (page 31), the painter is pictured in an over-sized armchair wearing a dressing gown, his feet set on a foot-warmer. For a long time, Empéraire led a dejected life. Too poor to buy himself the necessary art supplies, he was forced to paint on the most pitiful supports. Striving for recognition, harassing Victor Hugo, he near-

ly lost his mind when defective varnish destroyed a painting he had planned to send to the Salon. Finally, like his old friend Cézanne with whom he loved to go walking, he moved to Aix where he found peace in his cottage in the Gardes valley, not far from the Mont Sainte-Victoire. His *Paysage de la campagne d'Aix* can be read as an homage to the play of light that the painter so loved, and shows how, thanks to his strength of character, Empéraire was able to escape the tempting influence of Cézanne. His synthetic, almost dreamlike style belonged to him alone, as did his sense of color, allowing him to use different tones as if they were musical notes.

Cézanne's individualism did not prevent a group of artist friends from forming around him. Busy reinventing painting, they would meet on café terraces, alongside the babbling Aixois fountains and within the protective shade of the old parliamentary buildings. A companion of Empéraire and Cézanne, Paul Guigou (1834–1871) was a clerk for a notary

in Apt when the vocation to paint overtook him. Like many local artists, he was briefly attracted to Marseilles, which, due to its economic development that began with the Second Empire, vied with Aix for the status of regional metropolis. But the stark beauty of the Aixois countryside was irresistible to Guigou, who spent all his free time painting such country scenes as *Les lavandières devant Saint-Victoire.* This work shows the skill with which the artist rendered the crisp clear skies of Provence. A sensitive and faithful interpreter of the sites of Provence, Guigou was above all a realistic painter, similar to the southerner Frédéric Bazille, in whose company—when in Paris—he would meet with the Impressionists at the Café Guerbois. Succumbing to the delights of the capital, it was there that toward the end of his life Guigou became the drawing instructor of the baroness de Rothschild.

One could mention numerous other painters of Aix, among them Joseph Ravaisou and his *Château Noir* (page 39), or Louis Gautier and his *Sainte-Victoire vue du plateau de la Malle* (overleaf). A fruitful artistic scene, Cézanne's divine renderings, and the beauty of the town and its countryside would go on attracting great painters well into the mid-twentieth century. One example is the painter Charles Camoin, a native of Marseilles. When stationed at Aix during his military service, this future member of the Fauve group visited the aging Cézanne, giving rise to both a friendship and a rich correspondence.

It was also in Aix that, just before his death in 1954, André Derain made his swan song by creating the theatrical set and costumes for performances of *The Abduction from the Seraglio* and *The Barber of Seville*—a final adieu to the Provence with which he had fallen in love some fifty years earlier.

Vauvenargues

The village's grand chateau, with its architecture spanning the fourteenth to seventeenth centuries, belonged to Luc de Clapier, marquis de Vauvenargues, an eighteenth-century moralist. The village is located on the north side of the Mont Sainte-Victoire, and when Picasso bought the chateau in 1958, he called his art dealer and declared that he had just bought Cézanne's Mont Sainte-Victoire. "Which one?" his dealer asked, to which Picasso replied, "The original."[5] For him, the mountain itself was a work of Cézanne in "actual size." Two years later, Picasso painted his series entitled *Déjeuner sur l'herbe* at Vauvenargues. The painter is buried on the grounds.

Jean-Antoine Constantin, *Sainte-Victoire vue du quartier Beaufort.* c. 1780. Musée Granet, Aix-en-Provence.

"The sun is so terrifying here that
it seems as though objects
are pared down to silhouettes
not only in white or black but
in blue, in red, in brown, in
violet…Wouldn't our gentle
landscape-painters from Auvers be
happy here!"
Cézanne

Louis Gautier,
*Sainte-Victoire vue du plateau
de la Malle.* 1897. Oil on canvas.
Musée Granet, Aix-en-Provence.

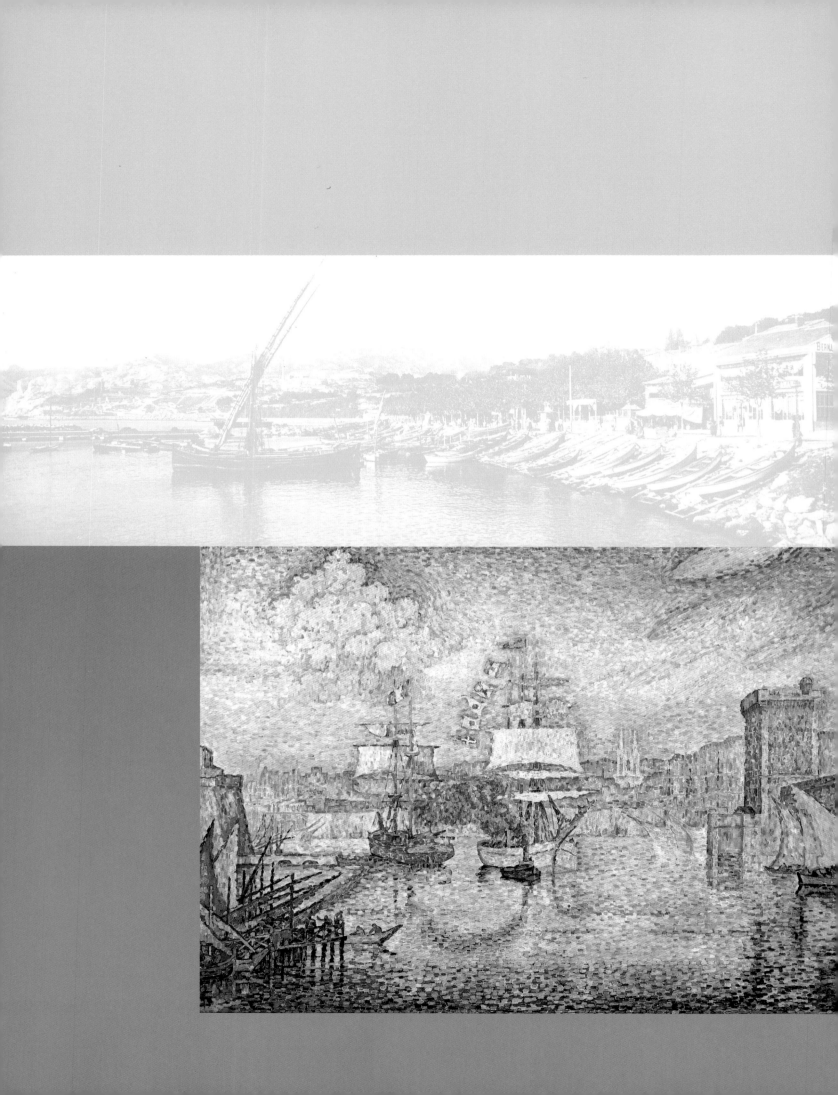

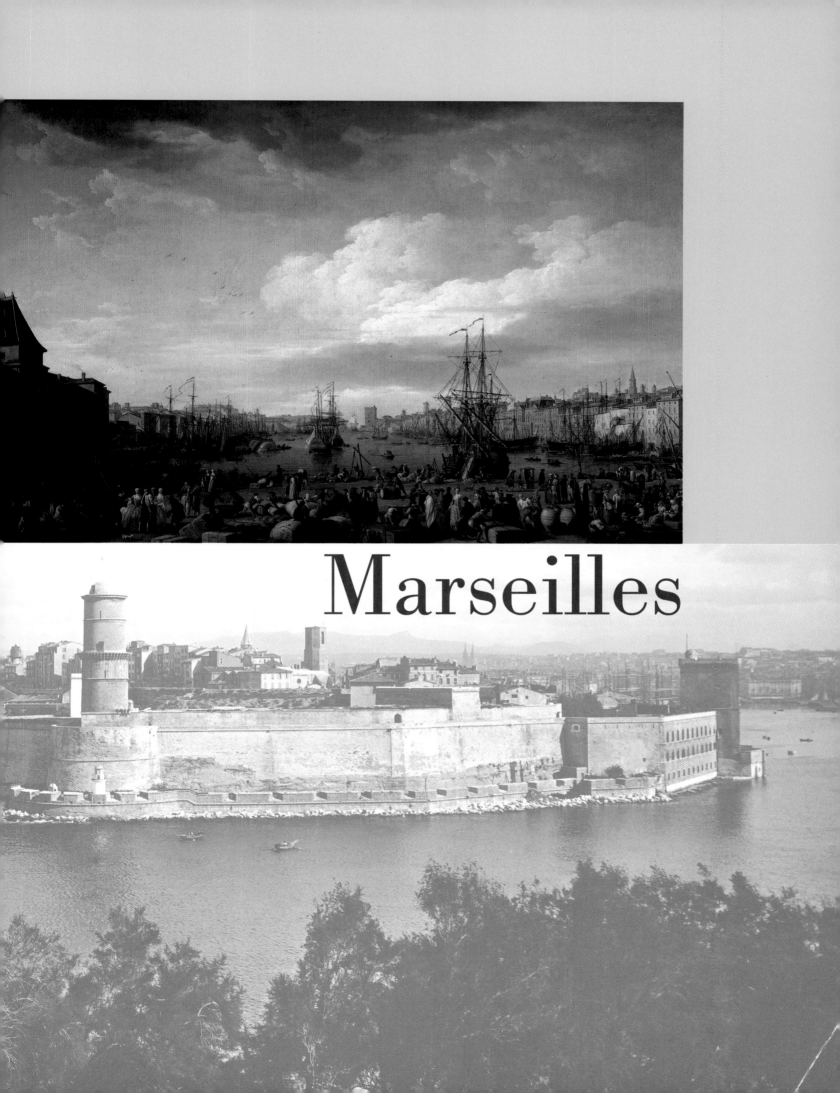

Marseilles

Preceding pages, top left:
The region of Marseilles, L'Estaque
and the fishing port at the end of the
nineteenth century.
Top right: Claude-Joseph Vernet,
Le Port de Marseille. 1754.
Musée du Louvre, Paris.
Bottom left: Paul Signac,
L'Entrée du Port de Marseille. 1918.
Musée Cantini, Marseilles.
Bottom right: view of
the cathedral and
the Saint-Jean fortress, taken
from the lighthouse at the end
of the nineteenth century.

Symbolically, on leaving his hometown Avignon (where, like his father, he had been a decorator of sedan chairs), it was in Marseilles that the great Claude-Joseph Vernet discovered the sea. From here, he set off for Rome where he was to take up an apprenticeship. After some twenty years in Italy, he returned to Marseilles and became the painter of the marine scenes that he is known for. His *Port de Marseille* (page 45) was one of the fifteen *Ports of France*, commissioned by the marquis of Marigny, Superintendent of Royal Buildings. Although the topography has hardly changed, it would be difficult today to find the elegant and idle high society, with its self-satisfied gaiety, depicted in this panorama. A rough sketch of the work presents much more local color, but Vernet preferred to "evict" the working-class characters in favor of the highly fashionable ones. We can see the end of the quai de L'Horloge, later the quai de la Fraternité, and further on the quai des Belges. Some one-hundred-and-fifty years later, this end of the boulevard La Canebière would be modified to house a building in the form of a ship's bow.

"La Samaritaine," as it was called, is where Albert Marquet painted some of his port scenes.

But that is getting ahead of the story. In the nineteenth century, artists from Marseilles, smitten by exoticism and by a desire to escape the materialism of industrial civilization, turned to the East. The port was an ideal gateway to the Orient, particularly since the French had seized control of Algeria in 1830. Artists such as Laurens, Crapelet, Barry and Ziem took off to the Middle East to paint their dreams. "Orientalism," as it was later to be known, had sown its seed.

Director of the drawing school of Marseilles from 1810 to 1845, Augustin Aubert has left us a painting titled *Environs de Montredon*. Similar to Vernet's paintings of the port, it reveals how the region around Marseilles has changed in the last century. Surprisingly, rather than focusing on the port or the sea, Aubert set up his studio on the edge of the countryside where he devoted himself exclusively to landscape painting; he also systematically orientated his students in that direction. He claimed that landscapes were not simply accessories to decorate the

Opposite: Augustin Aubert,
Environs de Montredon. 1824.
Oil on panel.
Musée des Beaux-Arts, Marseilles.

———

Emile Loubon,
*Vue de Marseille prise des Aygalades
un jour de marché.* 1853.
Oil on canvas.
Musée des Beaux-Arts, Marseilles.

background of paintings, but deserved to be considered as works of art in themselves. True to his word, some fifty years before Cézanne, Aubert made a simple umbrella pine the true subject of this picture.

Successor to Aubert at the Marseilles art school, Émile Loubon was in his day the accredited painter of the harbor. His *Vue de Marseille prise des Aygalades un jour de marché* (preceding page) is one of his finest examples. Even if the industrial era had not yet triumphed over the landscape, the idyllic settings of Vernet had already greatly changed: in the center of the picture two factory chimneys can be seen spewing out smoke. Aubert's umbrella pine, now a tiny apparition to the right of the painting, seems to be bowing to the chimneys. Yet the true subject of the work recalls Loubon's well-established reputation as a painter of

Auguste Aiguier,
*Effet de soleil couchant
au Vallon des Auffes..*
1858. Oil on canvas.
Musée des Beaux-Arts, Marseilles.

animals, with his depictions of flocks of sheep in the
Roman countryside and on the rocky plains of La Crau in
Provence. Here, the animals are shown on the Aygalades
path heading for the slaughterhouse next to the quays.

When Auguste Aiguier presented *Effet de soleil couchant
au Vallon des Auffes* at the Salon, it was declared that his
marine scene at sunset was without doubt the finest entry
and he walked off with all the jury's votes. It is hard not to
admire his deft treatment of light and how his golden
tones create a perfect harmony and unity of composition,
especially when one takes into account the fact that he was
self-taught. A modest hairdresser and wigmaker—he often
painted on boxes taken from his wife's millinery shop—
Aiguier lived on the coastal road La Corniche, whose
graceful curves run for nearly two miles along the clifftops

Jean-Baptiste Olive,
La Corniche à Marseille.
Oil on canvas,
Conseil Général des
Bouches-du-Rhône,
Hôtel du département.

between Marseilles and Cassis. For more than fifteen years his neighbors enjoyed watching his daily comings and goings as he took off to paint the area around the port and along the cliff paths. Aiguier was as inexhaustible as he was humble. His natural talent surmounted his lack of formal training and the critics accorded him the praise they did Loubon and Grésy.

A name better known to art-lovers is that of Jean-Baptiste Olive, who was born in the modest Saint-Martin neighborhood of Marseilles, where much of the population still spoke Provençal rather than French. Indifferent to his son's vocation, Jean-Baptiste's father, a wine merchant, wanted him to follow in his footsteps. A compromise was made, and the son entered the service of a decorator. All the same, he then started working with a painter of marine scenes named Julien, a "specialist of waves and storms" who taught him well, as we can see in Olive's *La Corniche à Marseille.* Olive, known not only for his Provençal marine scenes but his Venetian ones as well, was a remarkable colorist, favoring purplish tones and dazzling whites which he applied with a thick, sensual brushstroke. His sometimes uncontrollable colors have often been pointed out, but in fact he was not only a painter of color but also

of movement (he preferred painting La Corniche when the mistral was blowing). Turning his back on the other painters of the Marseilles School—who were still impregnated with the image of Vernet's serene compositions, or more dangerously, who flirted with the rigid, neoclassical *art pompier* of the period—Olive always chose excess over conventionality.

Today, still devoid of concrete eyesores, La Corniche remains one of the most beautiful stretches along the coast and it is easy to understand how it inspired later members of the Marseilles School as it had earlier inspired Olive. *La Corniche à Marseille* (page 2) by Edouard Crémieux gives no indication that its painter was first a student of Cormon, then of Bouguereau, both pillars of the Académie. In fact, although Crémieux began with scenes that were as dark as they were minutely polished, he soon developed a more vibrant palette. This quick and spontaneous sketch depicts the seaside cabin of a certain M. Borel, which was also painted twice by Olive. These cabins were actually more like country cottages since, just like today, the residential south side of Marseilles served as the

Adolphe Monticelli,
La Roche percée. c. 1881–2.
Musée des Beaux-Arts, Toulon.

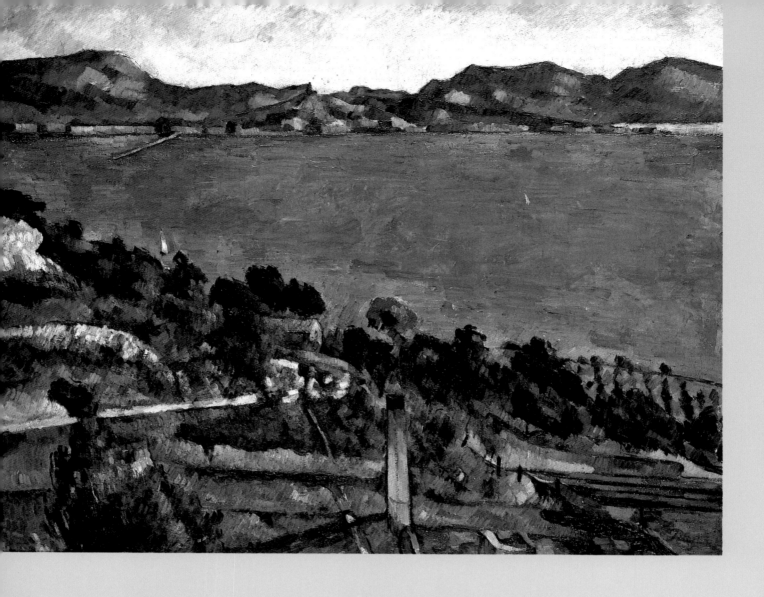

city's playground. The work is not analytical, but rather reveals a marked taste for thickly applied paint and a palette freed from the constraints of academic training. All that seems to matter here is the evocation, full of movement and color, of a place that the artist clearly loved.

Yet at the end of the nineteenth century not all the artists of Marseilles restricted themselves to idyllic visions or exaltations on the light of Provence. Some, anticipating what was to come, ventured on to a more deliberately expressionist path. Beyond his studies with Ziem, Adolphe Monticelli always remembered the colors of his youth spent in the rocky countryside, and his thick and lively brushstroke earned him the admiration of van Gogh (with whom he shared the anguish of never being understood by his contemporaries). Splitting his time between Paris and his beloved Marseilles, he became friends with Cézanne in the early 1880s and often went walking with him, especially near L'Estaque. Their approach to the subject, however, would always be radically opposed. To Cézanne's decomposition of motifs into structural elements, Monticelli responded with a diluting of the subject, push-

ing to the extreme the audacious *veduta* developed by such eighteenth-century Venetian artists as Francesco Guardi. The site painted by Monticelli, *La Roche percée* (page 51), was also called "Marot's leap." The hollowed-out center of the cliff allowed for boats to pass through—a spectacular setting that was bound to seduce painters in search of original compositions. Monticelli chose to treat the subject in a dramatic dimension and, seen against the light, the humble boat could almost be Dante's. By ending with compositions that took so much liberty with academic tradition, the nineteenth century seemed to announce the dazzling boldness that would mark the painters of the twentieth century.

Born into an upper-class family in Marseilles, Alfred Lombard had a very diverse career. After training in his native city and a long excursion with the Fauves, he went on to decorate the chapels of the cruise ships *Atlantique* and *Normandie*. One of the first known paintings of Lombard, *Le Bar N... à Marseille* (page 59), was painted in 1907 when the artist was only twenty-three. It reproduces all the charm of a bistro from one of the city's old neighborhoods, in a perfect demonstration of Fauve technique. Lombard had attended the 1905 Salon d'Automne in which the Fauve painters first exhibited, and in this work he deliberately distances himself from descriptive reality to address the senses through shape and color alone. A few years later, the sensitive nature of his brushstroke brought Lombard to the attention of the German Expressionists. Quite remarkably, the ambiance of this painting can still be found in the Panier quarter of old Marseilles, even if the fishermen who traditionally inhabited the place no longer live there. A lane called the montée des Accoules leads up to the steep neighborhood crowded with its tall, old buildings, where laundry is still hung from the windows. Following a classical approach in his works, Lombard chose a close vantage point, giving the viewer the impression of being a part of the scene.

The opposite of Lombard, Albert André, with his *Rue Saint-Ferréol, le soir,* 1917, takes us out in the evening on to one of the most elegant streets of Marseilles, peopled with well-heeled passers-by, one of whom turns toward the viewer, as if aware that the painting is opening a window between two worlds. Although he studied in Paris, where in the 1890s he had the opportunity to meet the most promising names of French painting, Albert André had always known the Midi. In 1913, he presented his landscapes at the Belgian avant-garde "Exposition de la libre

Paul Cézanne,
L'Estaque vue du golfe de Marseille.
Oil on canvas.
Musée d'Orsay, Paris.

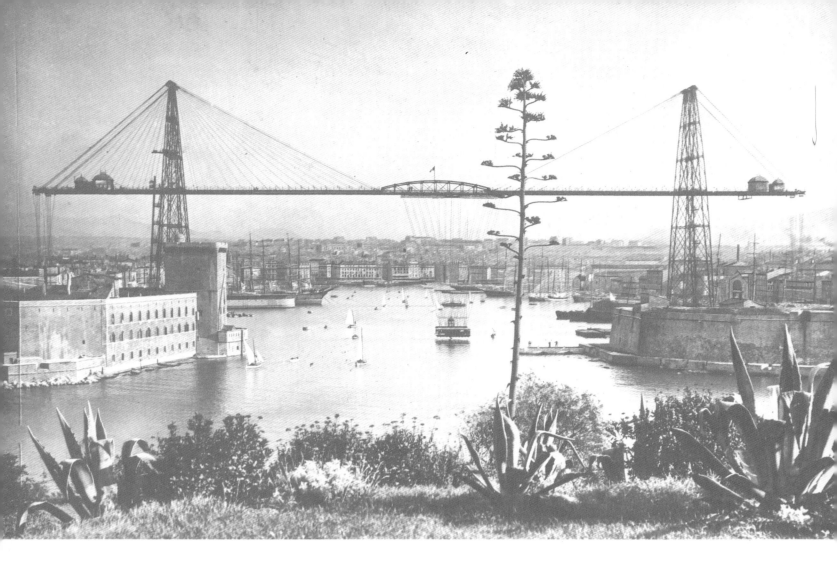

The transporter bridge
and the old port at the end
of the nineteenth century.

——

Opposite: V. Guillaume,
Le Transbordeur. 1928,
Oil on canvas.
Musée des Beaux-Arts, Nancy.

Esthétique," the theme of which was "the interpretation of the Midi." Then, having completed his military service, André finally moved to Marseilles in 1917. Here we are far from the local color and exuberance that visiting painters looked for in Marseilles after their "pilgrimage" to L'Estaque and the Vieux Port. The beautiful uniform façades dating from the time of Louis XV depicted in this work can still be admired on rue Saint-Ferréol, today a pedestrian street. Complex painter that he was, André always stayed close to the Fauve movement without, however, completely adopting its technique. His process seems especially complex in this painting, since it is unclear whether everything is motionless or in movement, and the figures, illuminated by the light streaming from the windows above, are alternately anonymous and haunting. Close to Renoir, in whom he saw a master, André seems to have rendered an implicit homage to the painter from Cagnes.

L'Entrée du Port de Marseille (page 44) by Paul Signac can be dated to 1918, thanks to a letter from Signac to the writer Félix Fénéon. It was during that same summer in Marseilles that Signac met the young critic Albert Aurier who had written favorably about him in the literary review

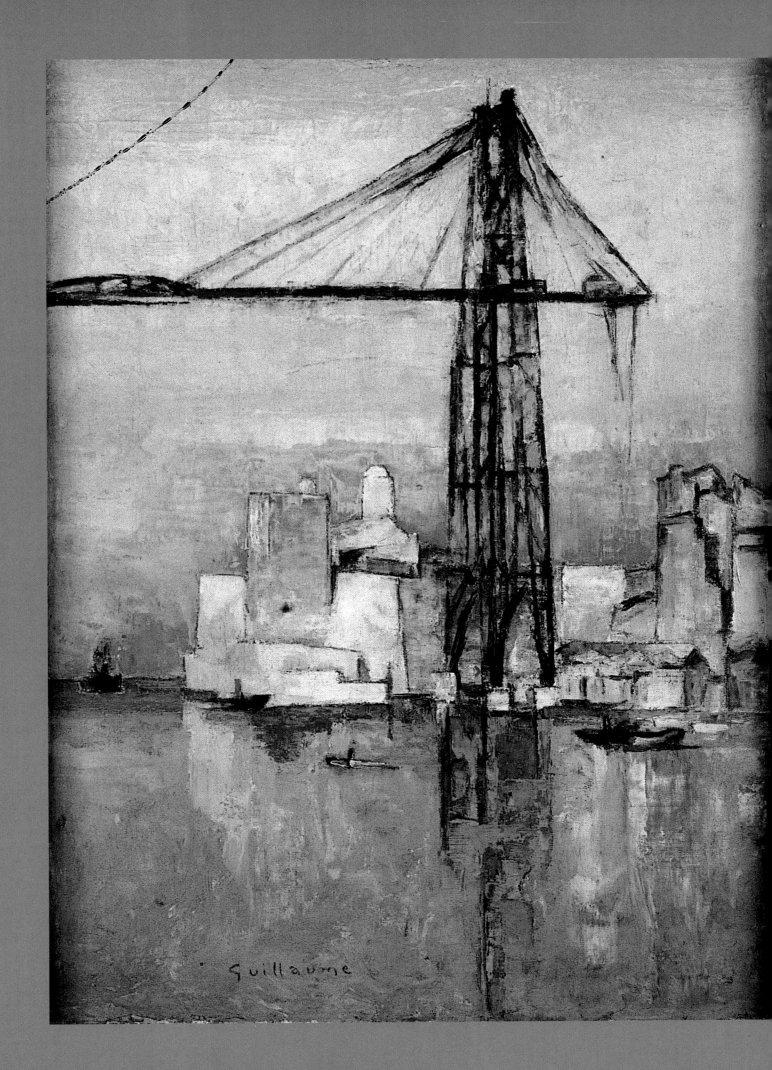

Guillaume

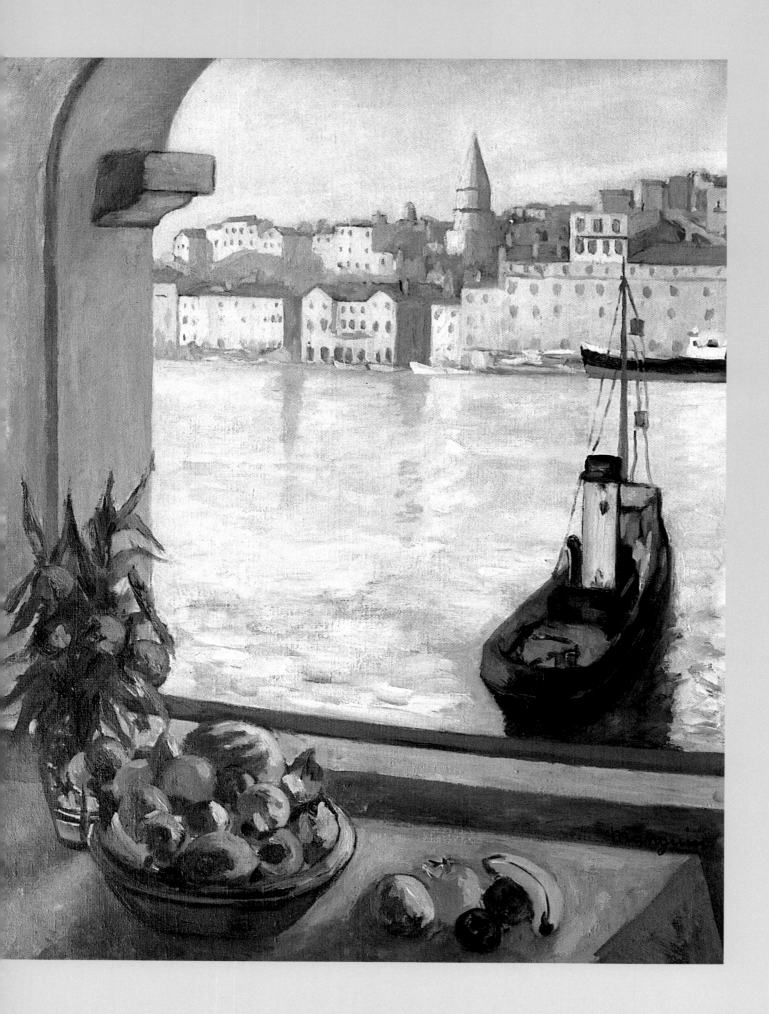

Mercure de France. Aurier, who died tragically at the age of twenty-seven, was in the region to write a book on van Gogh. Signac had already depicted the same subject some twenty years before. He must have used preparatory sketches from an earlier period, since during the war, for reasons of national defense, it was forbidden to paint or draw in the ports (in fact, Signac's activities brought him considerable trouble from the administration). Signac, who loved to study the changing effects of sky and water, was inspired not only by Marseilles, but also by such ports as Venice, La Rochelle, Genoa and Rotterdam, always with an eye to the nature of light. Here, the regular, even brushstrokes show the distance between a pointillist technique and the spontaneity of Impressionism. A passionate sailor, Signac loved to sketch his scenes on the open sea. One point remains a mystery—the transporter bridge built in 1905 never appears in the views of the Vieux Port painted after that year by Signac. Like many artists careful to paint the harbor in the most picturesque of fashions, Signac simply eliminated the bridge.

Guillaume did not share Signac's aesthetic choice and

Opposite: Henri Manguin,
Fenêtre sur le Vieux-Port.
Musée Ziem, Martigues.

———

Mathieu Verdilhan,
Le Vieux-Port.
c. 1925.
Musée Cantini, Marseilles.

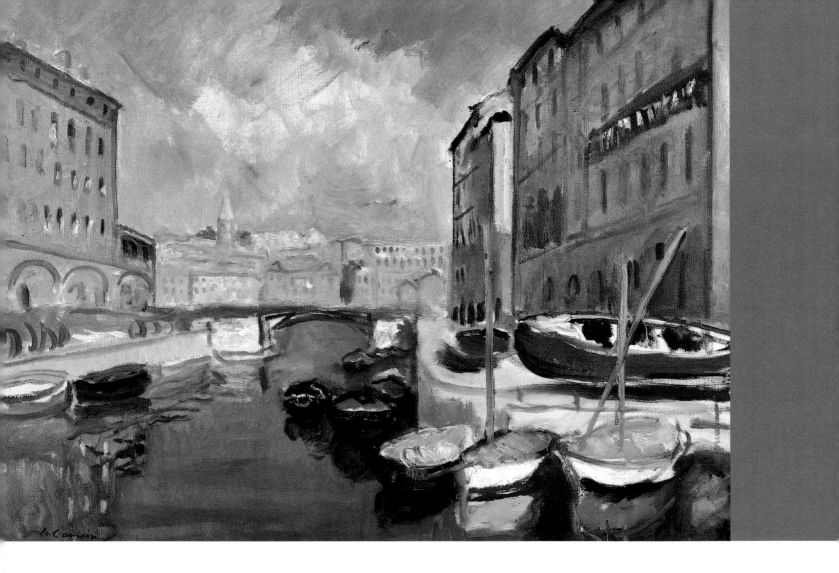

even titled one of his paintings *Le Transbordeur* (page 55). Built by the Établissements Arnodin—which had already erected transporter bridges in Rouen, Rochefort and Nantes—the bridge stands on piers of over 250 feet between the two citadels constructed by Louis XIV's military architect Vauban. Perhaps it was no coincidence that the bridge was inaugurated on Christmas Eve 1905, as traditionally Christmas is a day of cease-fires. The project had incited a true battle between the Ancients and the Moderns of Marseilles. The latter were firm supporters of this work of art so necessary to commerce, while the former considered it a sacrilege even to think of violating the beauty of Lacydon Creek, where in approximately 600 B.C. the Greeks had established Massalia. Apparent in both his choice of composition and the way in which he carried it out, Guillaume seems to have been on the side of the Moderns. He chose to depict only one pier, to the right of which can be seen the old customs house, which looks as if it is being crushed by the iron giant. At any rate, the bridge that so divided the people of Marseilles would not survive World War II.

With his friend Charles Camoin, Albert Marquet painted in Menton, Cassis, Agay and, most frequently, in Saint-

Tropez. However, when he was declared unfit for military service during World War I, the artist chose to go to Marseilles, a city he knew from having stopped there on his way to Algiers. He moved into Monfort's studio on the quai de Rive-Neuve and remained there until they had a falling out. Undeterred, he would often return to Marseilles, thanks to his friendship with Alfred Lombard. He had a certain influence on a number of local painters, such as Mathieu Verdilhan, who will be discussed below. Marquet loved to paint from the windows of the Hôtel Beauvau that overlooked the harbor and its surrounding buildings. Around 1916, he painted the *Port de Marseille,* which now hangs in the Musée Cantini. The work's elaborate play of orthogonal lines clearly indicates Marquet's primary interest. In the distance, the Pharo, Fort Saint-Jean and, most notably, the transporter bridge eliminated in paintings by Signac from the same period can be seen. Pictured as anonymous silhouettes, the passers-by bring a touch of color that contrasts with the translucent stretch of water. In 1918, Marquet, who was one of the greatest twentieth-century marine painters, completed five more

Alfred Lombard,
Le Bar N… à Marseille. 1907.
Musée de l'Annonciade, Saint-Tropez.

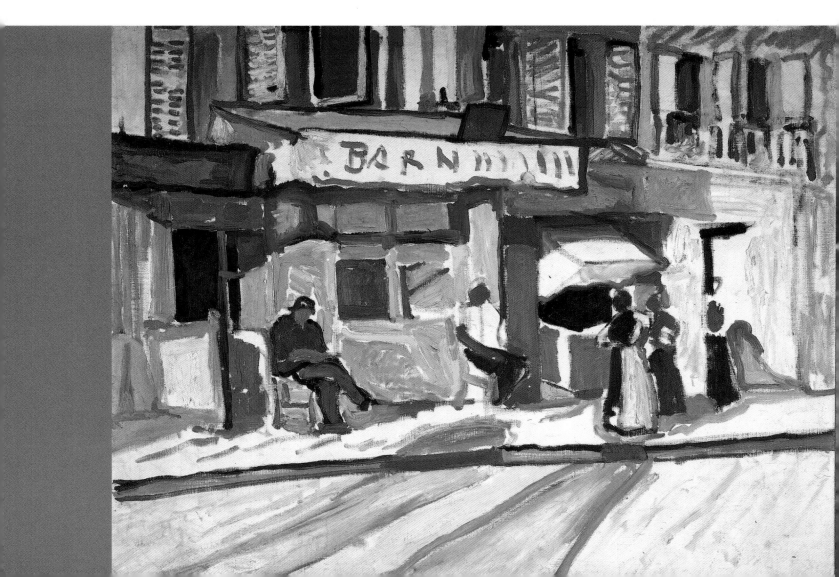

pictures with the same point of view as the *Port de Marseille* that now hangs in the Musée de l'Annonciade. In a cocoon-like ambiance worthy of Japanese etchings, the outline of the city is suggested by a few emblematic elements such as the silhouette of the Church of Notre-Dame de la Garde, which towers above the city and the docks of La Joliette.

Henri Manguin spent the winter of 1925 in the studio of his old friend Marquet, whom he had met at Gustave Moreau's studio. It was from Marquet's window that he painted the magnificent *Fenêtre sur le Vieux-Port* (page 56). In Saint-Tropez, some twenty years earlier, Manguin had shared with Marquet and Dufy the theme of boats flying their colors. But here the painter is concerned with another favorite subject of Fauve painters: the open window, so important for Braque and Matisse. The viewpoint had already intrigued Manguin in an earlier picture that was smaller in format. Here, different from the smaller work, most of the painting is devoted to a still life where the most intense tones—red, green and yellow—are freely combined. In response to this frenzy of color is the tranquil palette of the buildings reflected in the water. This theme pleased Manguin so much that he would repeat it the following winter in Toulon, and then again the following year in Saint-Tropez.

Throughout his long career, Mathieu Verdilhan continually commuted between Paris and Provence, but he had grown up in Marseilles, and this is where he was influenced by Impressionism. Later, he migrated closer to Fauvism, as can be seen in *Le Vieux-Port* (page 57). Verdilhan's catalogue raisonné counts nearly one hundred and forty paintings depicting this same subject. The Vieux-Port appears in a bare construction held together by a complex play of diagonals and verticals. Meeting Marquet in 1916 was a decisive moment for Verdilhan, and the influence is visible here in his use of flat planes and forms shadowed in black. Unfortunately, this fine artist was so critical of himself that he regularly destroyed much of his work. During the same period that he painted *Le Vieux-Port,* Verdilhan also decorated the Provence Pavilion for the Exposition des Arts Décoratifs and executed a panel for the city's opera house.

Another Fauve attracted to Marseilles was the cosmopolitan Charles Camoin, who in turn came to the city to join his artist friends. In the *Canal de la Douane* (page 58), he has left us evidence of the open space that once faced the town hall on the Vieux-Port, unfortunately since filled in.

Albert Marquet,
Terrasse de l'Estaque.
c. 1916. Oil on canvas.
Musée des Beaux-Arts, Nantes.

It would be impossible to discuss Marseilles without paying tribute to the exceptionally inspiring L'Estaque, the little fishing village that was so popular with writers and painters from the 1850s up to the First World War. Today the village has sadly given way to an industrial suburb. As early as 1902, Cézanne already noted the increasing industrialization of L'Estaque, something he pointed it out in a letter dated September 1, 1902: "I remember the shore at L'Estaque perfectly and it was so picturesque. Unfortunately, what is called progress is nothing but an invasion of bipeds who never stop until they have transformed everything into hideous quays with gas lamps and—what is worse—with electric lighting. What a time we are living in!"[5]

Cézanne often went to L'Estaque, and during his time here produced such stunning paintings as *L'Estaque vue du Golfe de Marseille* (page 52). Staying there regularly between 1870 and 1885, he often invited Renoir and Monet. These illustrious visitors would alone have been enough to transform the place into a "shrine" of modern painting, but the adventure took up again some twenty

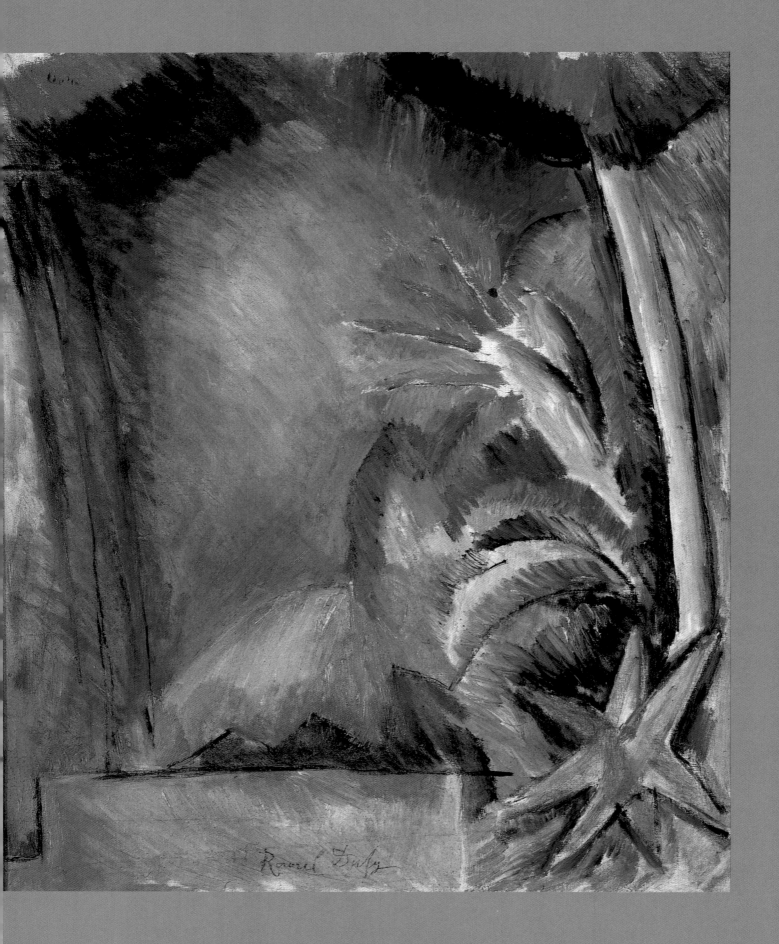

years later when, in 1905, the Fauves started making frequent visits. André Derain was the first to make the pilgrimage in the footsteps of Cézanne. In their quest for light and pure color, the Fauves were primarily influenced by van Gogh. On the other hand, the memory of Cézanne, so present in L'Estaque, was largely instrumental in paving the way to Cubism. Georges Braque spent the fall of 1906 through February 1907 in L'Estaque. He left with a series of marine scenes in an elegant Fauvist style. Nevertheless, the Cézanne retrospective at the 1907 Salon d'Automne, along with his introduction to Picasso, radically altered Braque's direction. When he returned to L'Estaque the following summer, he painted a series of landscapes with grand gestures and a simplified palette, where perspective tended to dissolve: Cubism was on the horizon. After his discovery in L'Estaque, Braque declared that it was in the Midi that he felt most elated.

Dufy made the trip with Braque, and this stay would also reinforce in the former a need for structure, although it would not lead him quite as far as Cubism (developed on his return to Paris). In *Arcades à L'Estaque,* Dufy depicted the columns of the Hôtel Mistral painted a year earlier by Braque, but paid attention primarily to their arabesques and other decorative aspects of the building. In fact, this evolution toward an art freed from Cubism's obsession with volume foretold the future activities of Dufy who, shortly after, devoted himself to wood-engraving and fabric design for the great Parisian couturier Paul Poiret. Dufy had not yet reached the height of his painting of horse races and regattas, but his art was already irresistibly evolving toward softer tonalities.

Naturally, those painters living in Marseilles often escaped the city center and the Vieux-Port and set up their easels in L'Estaque. Albert Marquet's stays in the village are not precisely dated, but the *Terrasse de L'Estaque* (page 61) is characteristic of the majority of his paintings done here—views from the terrace of the Hôtel de la Falaise, which early in the century, thanks to its magnificent setting, became an especially prized site. If not for the warship on the open sea, it would be easy to believe in this idyllic vision.

Raoul Dufy,
Paysage de L'Estaque.
1916. Oil on canvas.
Musée Cantini, Marseilles.

Les Calanques
and la Corniche
des Crêtes

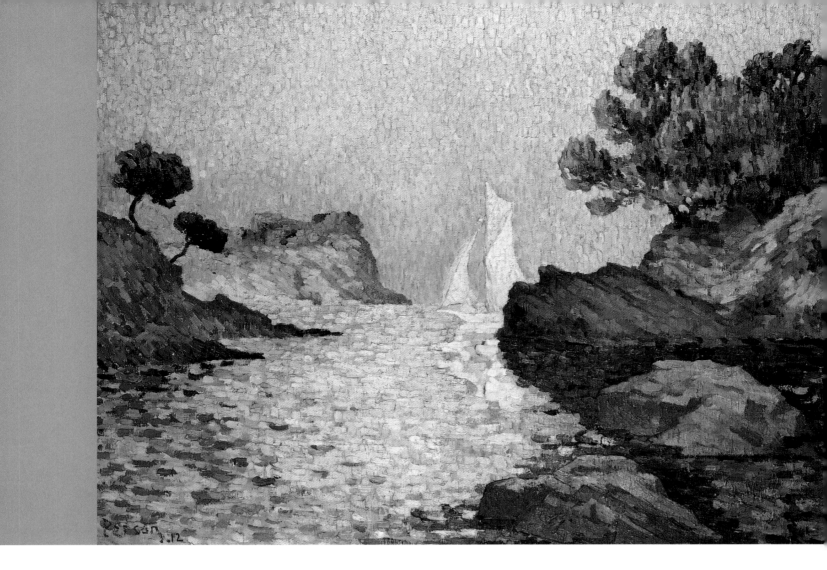

Cassis

With its quays of colorful houses, its terraces and its fishermen (now replaced by yachtsmen), sheltered from the steep cliffs of the so prettily named "roguish" Cap Canaille, Cassis seduced many painters in the first years of the twentieth century, most notably André Derain. It was here that he painted more and more tightly structured landscapes, a consequence of Picasso's and Cézanne's influence. Yet it was thanks to Matisse that Derain discovered the Midi in 1905, and above all Collioure. Discovered at the 1905 Salon d'Automne where he exhibited in the famous "Cage aux Fauves," Derain became one of the most innovative and admired painters of his time. From his stay in this lovely village he has left us *Pinède, Cassis* (page 68–9), a pine forest painted in 1907, the year after his trip with Braque to L'Estaque. Despite his friend's example, Derain resisted the temptation of Cubism in favor of a frenzy of color that can be appreciated in this work. Yet, this painting shows that the artist is already moving away from the arabesque motif that characterized his work in Collioure to a more classic approach, as can be seen in the restricted palette and the

Opposite: André Derain in his studio.

———

Charles-Henri Person,
La Calanque. 1912.
Oil on canvas.
Musée de l'Annonciade, Saint-Tropez.

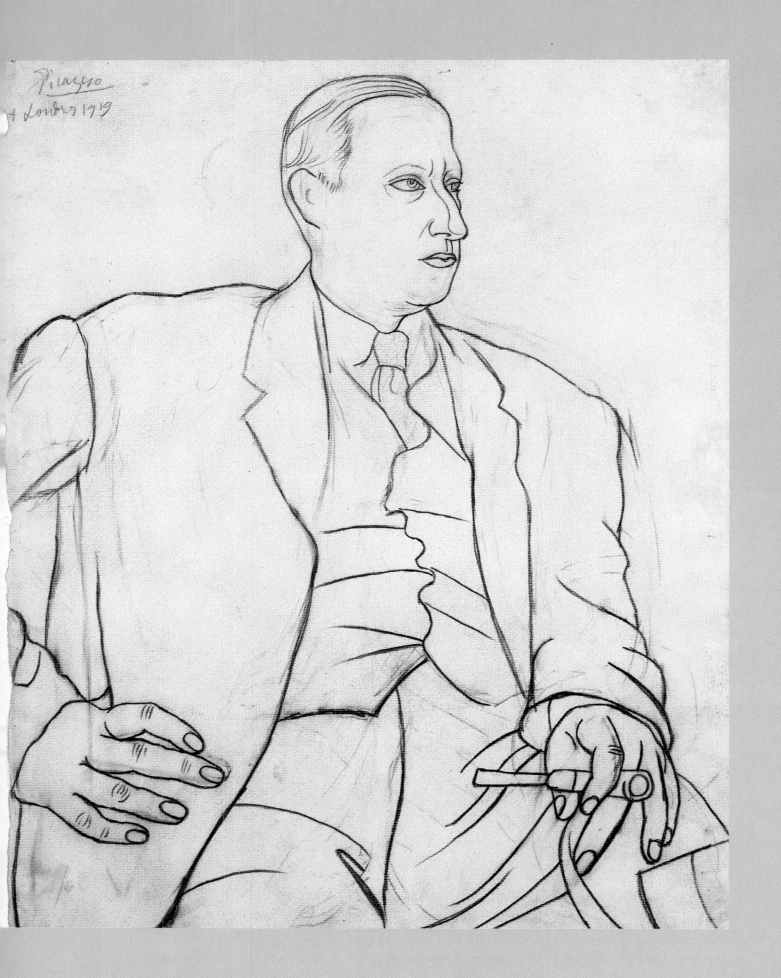

tightness of the composition. The colorful harmony constructed around deep greens and orange-tinted reds is quite remarkable, as are the contrasted and outlined shapes that recall Gauguin's carefully balanced art. The perspective broken by the three tree trunks is evocative of the great Cézanne and contributes to making this work one of Derain's finest landscapes. In a letter to Vlaminck, Derain wrote that he found the landscapes of Cassis more beautiful than those of Collioure, adding that he had no other desire than simply to paint a gray that breaks away from the sea.

Nearby, somewhere between Cassis and Marseilles, the rocky coastline inspired Charles-Henri Person's *La Calanque* (page 65) in 1912. Person's boat, which can be detected behind the rocks, hints at the artist's passion for sailing—which he shared with Signac. It was Signac who encouraged the neo-impressionist technique seen here, and who introduced his friend to the Midi, where Person found the majority of the subjects for his paintings. It was also through Signac that Person discovered Saint-Tropez, where he set up his studio on the harbor in the Château Suffren.

Opposite: Pablo Picasso,
Portrait of André Derain.
1919. Graphite drawing.
Musée Picasso, Paris.

———

Georges Braque,
La Ciotat. 1907.
Musée National d'Art Moderne, Paris.

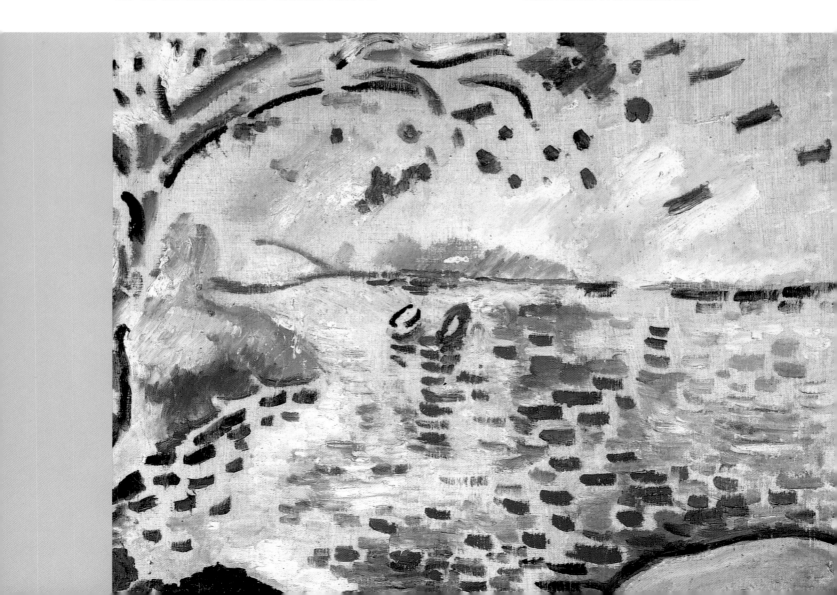

"There are splendid landscapes here, certainly more beautiful than the ones of Collioure. I don't feel like doing anything but a gray that hovers over the sea."
Derain to Vlaminck
on the subject of Cassis

André Derain,
Pinède, Cassis. 1907.
Musée Cantini, Marseilles.

La Ciotat

La Ciotat, as it was known by the Fauve painters in the early 1900s, has changed in appearance. Today, the seaside resort has not only become a popular tourist destination, but its once-flourishing shipyards, splendidly inaugurated in the 1870s by the baron de Lesseps, have been left to ruin. In the summer of 1907, Braque spent time in La Ciotat and left with a series of imaginative, small-format seascapes in a pure Fauve tradition (*La Ciotat*, page 67). Numerous players in the world of Modern Art arrived in turn. In 1921, fourteen years after his old friend Braque, Derain spent the summer here before going on to Sanary. Nicolas de Staël also sojourned at La Ciotat after World War II.

Sanary

A pleasant seaside resort, Sanary had all of the advantages necessary to attract artists: a lovely array of pink- and white-faced houses, pretty fishing boats anchored near the quay, and a bay sheltered from the mistral by the surrounding hills. As of 1907, Moïse Kisling, fleeing the too fashionable Saint-Tropez, found refuge here and was soon followed by a number of his more or less famous colleagues. In 1925, Jean Puy painted the picturesque *Marché à Sanary*, of which several versions exist.

It was during the same period that in addition to a number of painters—including the great traveler Derain, who spent the summer of 1921 in Sanary—the British writer Aldous Huxley and his circle moved here. They would soon be followed by a community of German writers fleeing Nazism, including Stefan Zweig and Thomas Mann.

Jean Puy,
Marché à Sanary. 1925.
Musée de l'Annonciade,
Saint-Tropez.

Toulon

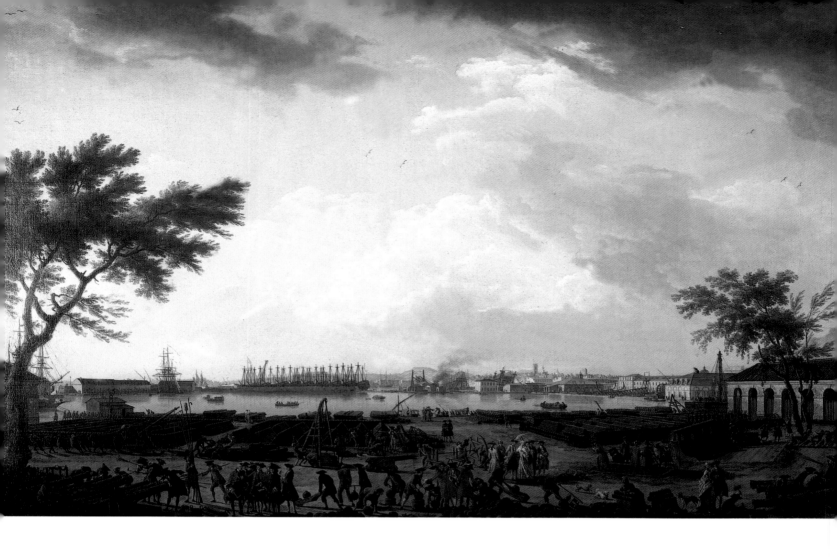

Claude-Joseph Vernet's fine painting *Première vue de Toulon, vue du Port Neuf,* viewed from the angle of the artillery depot, makes for a reliable image of what the port of Toulon might have looked like before being hit by the tidal wave of the Industrial Revolution. This work is one of the fifteen paintings from the *Ports of France* series, commissioned by the marquis of Marigny, Superintendent of Royal Buildings. It reveals a multitude of details about the organization of shipyards at that time, without omitting the inevitable group of elegant idlers, a colorful touch that livens up each of Vernet's *Ports.* The Toulon Arsenal, shown here in the height of its glory, was reorganized in the early eighteenth century having long been ignored in favor of Marseilles, which had an impressive arsenal of galley ships.

The title of the painting *La Petite Rade de Toulon* (page 76) by Vincent Courdouan, can be explained by the fact that Toulon has two harbors or *rades,* the smaller, "*la petite,*" having supplanted the larger as a result of dredging and the disappearance of the sailing squadrons. Two years before this picture was painted, a long breakwater had transformed the Petite Rade into a huge basin. A magnificent panorama can be viewed from the Corniche de

Balaguier, between the old gunpowder depot of Mourillon and the Tour Royale de la Mitre, set against a background of Mont Coudon and Mont Faron. Today, the Corniche du Mourillon has been developed into a tourist and recreational area. As for the Tour Royale, the top two floors were destroyed during the Allied bombings. This is a great loss as, built under the orders of Louis XII, it was one of the last examples of medieval fortifications before the appearance of the bastion. Not long after its completion, the tower became the possession of the Hapsburg Emperor Charles V when he seized Toulon in 1524. When looking at this tranquil landscape from the time of Courdouan, it is hard to imagine that in November 1942, the French fleet would scuttle sixty of it finest ships here, managing to save only a few submarines, including the famous *Casabianca*. For its part, Mont Faron remains unchanged, still covered with pine forests. From its summit one can see the scenery of the Provençal Alps, and also the immense harbor, immortalized by Courdouan. Adorned with olive groves,

Opposite: Claude-Joseph Vernet, *Première vue de Toulon, vue du Port Neuf.* 1756. Oil on canvas. On loan from the Musée du Louvre to the Musée de la Marine, Paris.

View of the Saint-Mandrier in the 1870s.

pine trees and scrubland of holm oak, Mont Coudon proudly towers above Mont Faron by over fifteen hundred feet. Like the harbor, the serenity of the lower mountain was disturbed by the harrowing trials of the war when its fort was captured by the Allies, for whom it was the key to entering the fortified camp of Toulon. These historical points aside, this highly sensitive work is the archetype of landscape painting as developed at the end of the nineteenth century by the artists of Toulon—all influenced by the at once classical and naturalistic art of Vincent Courdouan. *La Rade de Toulon* (page 80), painted again by Courdouan, addresses the same panorama but from a more distant perspective, this time viewed from the coast between the peninsula of Saint-Mandrier and the village of Les Sablettes. In this lovely composition, where the oblique lines of the lateen sails echo those of the cabin roofs, the obligatory palm tree appears—as in so many works by local painters—following to the enthusiasm for all things oriental in vogue at the time. The fishing village of Les Sablettes, located on the sandy isthmus that links Saint-Mandrier to the mainland, was razed to the ground in 1944, but later rebuilt as a seaside resort. The little

Vincent Courdouan,
La Petite Rade de Toulon. 1882.
Oil on canvas.
Musée des Beaux-Arts, Toulon.

fishing harbor of Saint-Mandrier was luckier, and the view painted by Courdouan can still be seen from the cemetery. Eugène Dauphin painted *Les Sablettes* (page 73) the same year as Courdouan, and the latter's influence is clearly apparent. And in Raphaël Ponson's *Guinguette aux environs de Toulon,* we find the now familiar palm trees, this time standing out against an azure sky, adding local color to the artists's picturesque rendering of an open-air dance hall.

As time passed, painters shifted their attention from the wide panoramas of Toulon and its surroundings to the lively colorful city itself. In his *Port de Toulon* (page 82-3), Louis Nattero reinterpreted one of Toulon's most famous landmarks, the quai Cronstadt, adorned by the extraordinary Hôtel de Ville and its entrance supported by Puget's atlantes. The atlantes, seen here in profile, give an undulating movement to a composition otherwise heavily punctuated by vertical and diagonal lines. Pierre Puget, who had been commissioned to carve the atlantes in 1656, used dock-hands as models, making these sculptures unique: they were the first in the history of sculpture to put behind the role of conventional figures, becoming instead allegories for the strength of Toulon, built by the efforts of

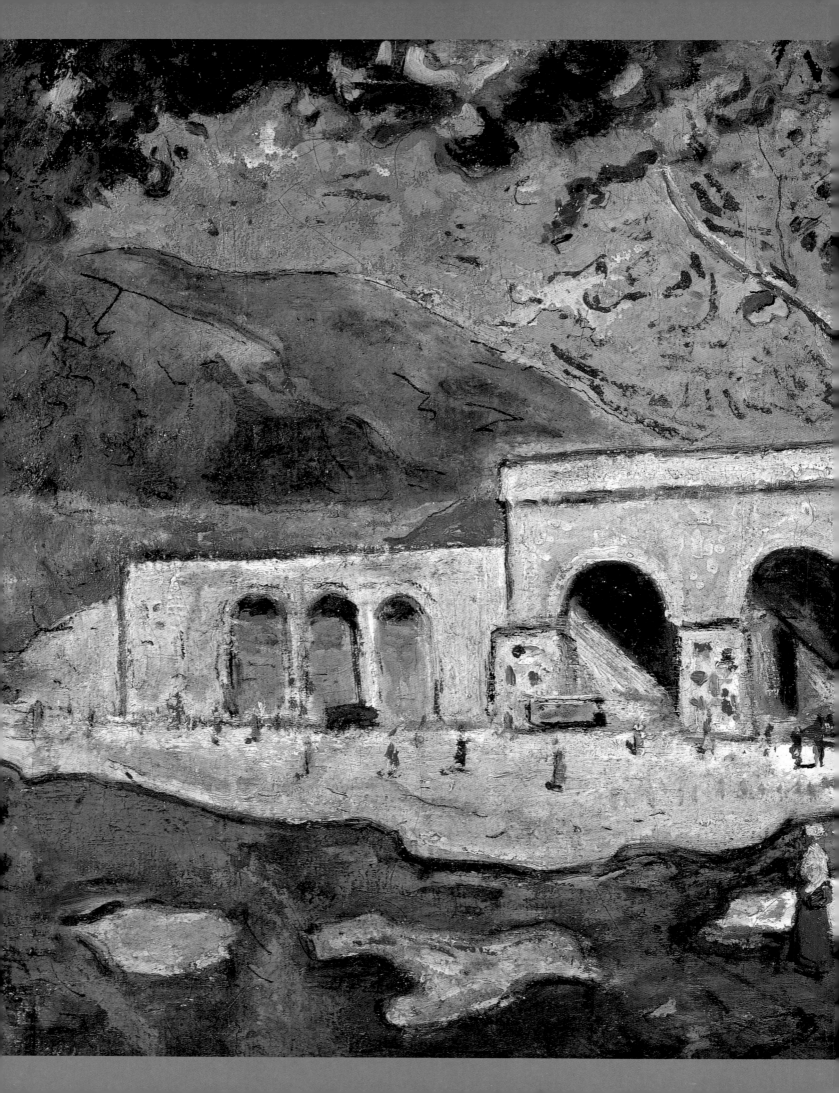

"Hills of pine and cork oak come down to gradually die out in the sea, and in passing are treated to sand of a fineness unknown on the coast of the English Channel... Charmingly intimate spots crowd next to great magical and decorative traits. Yes, these are the two epithets that best describe the sensations I have experienced up until now."
Letter from Cross to Signac

Joseph Mange,
Anciennes portes Notre-Dame à Toulon.
Oil on canvas.
Musée des Beaux-Arts de Toulon.

men and the resources of the sea which they face. The town hall was virtually razed during the Second World War, but the atlantes miraculously survived the fiery skies. The force of Nattero's painting, however, comes as much from the rich and powerful technique as from the scene depicted. While steeped in numerous influences, Nattero's sky and the figures, sketched here with *brio*, recall the art of Eugène Boudin. Following the example of Impressionism, Nattero goes beyond the "master of skies" and frees up his technique, working with his palette knife and alternating impasto with a more fluid use of paint.

During the first thirty years of the twentieth century, leading painters came to join the ranks of the Toulon School, already endowed with talent. Between 1917 and 1920, Moïse Kisling stayed near Toulon, while Othon Friesz sojourned first in Cassis, then in La Ciotat, before discovering Toulon late in 1913. Having moved to Toulon after the armistice, it was here that he met his wife. Friesz set up his studio in the port and Toulon became his major place of creation for some fifteen years. A finely drawn work, *Le Jardin au Cap Brun* (page 72), painted in 1930, seems to have been done on his estate Le Jarres, on the north side of the hills of Mourillon, facing the Mont du Coudon which stands above the plain between Toulon and

Hyères.

A local emulator of the Fauves, Joseph Mange's vocation was born under the best of auspices. The inspiration to paint came through his discovery of Cézanne at the Musée Granet. Initially an admirer of the Impressionists and Seurat, he was unable to resist Signac's influence and took a detour through pointillism arriving at Fauvism in paintings such as *Anciennes portes Notre-Dame à Toulon* (page 78-9). Never straying far from his home town, Mange occasionally abandoned painting for photography, but was unable to earn a steady living. His financial situation was often so precarious that he would paint with mediocre paints on cardboard found in the garbage to create his nevertheless superb compositions. This work is a somewhat rare example of the Fauve technique in a local school that, while mixing with artists from the avant-garde of French painting, remained attached to the pictorial methods from the end of the nineteenth century. The boldness of Mange's palette, along with his turbulent brushstroke, makes him a gifted if somewhat modest follower of the Fauves.

Opposite: Vincent Courdouan,
La Rade de Toulon. 1884.
Oil on canvas.
Musée des Beaux-Arts, Toulon.

———
Toulon harbor at the beginning of the nineteenth century.

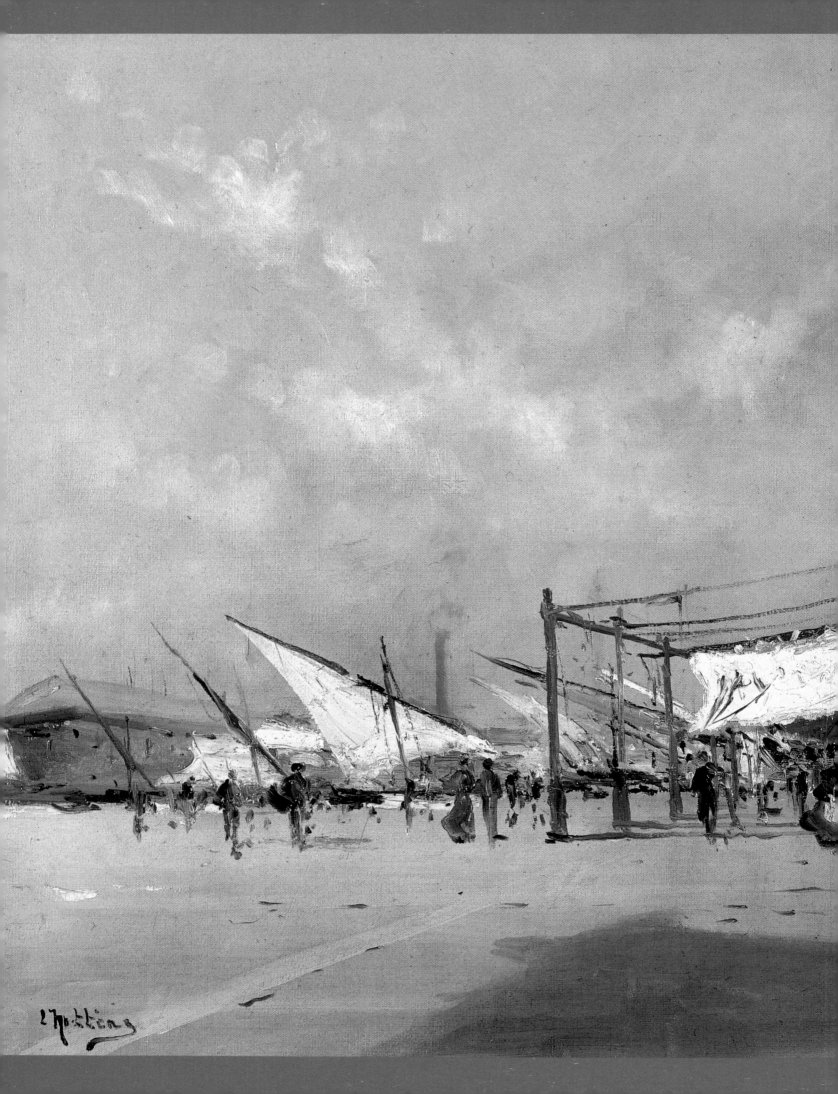

Louis Nattero,
Port de Toulon. Oil on canvas.
Musée des Beaux-Arts,
Toulon.

A. Dunoyer de Segonzac

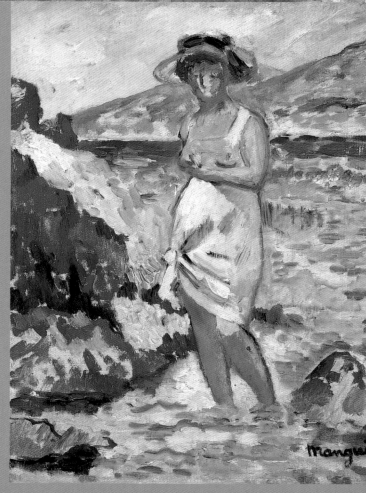

Manguin

Between le Massif and la Corniche des Maures

Le Lavandou

Cogolin

Grimaud

Le Lavandou

Painters were sure to be fascinated by the surroundings of Le Lavandou and the famous "Moors" coastal road, the Corniche des Maures, where the Massif's foothills plunging into the sea alternate with beautiful beaches. Having first adopted a divisionist technique, Henri-Edmond Cross was converted to painting with Signac's large brushstroke after moving to this region that he grew to love so much. In 1891 he first lived in Cabasson near Le Lavandou then moved to Cavalaire. Noting at the time that the beaches were deserted in summer, he happily took advantage of the peacefulness and tirelessly painted the Baie de Cavalaire. The version exhibited at the Musée de l'Annonciade dates from 1906. In spite of the fragmented brushstroke, here Cross abandoned the rigorous pointillist approach, preferring to relay the image of an idyllic, yet simple, happiness. He wrote of Cavalaire, "Elegance does not only reside in the pines that come out of the sand and in the half-moon formed by the coast. But how eternally beautiful these are!" In fact, like Signac, Cross did much to attract his artist friends to the region by stirring up their desire with his let-

Preceding pages, top left:
Dunoyer de Segonzac,
Paysage de Grimaud.
Pen and watercolor. 1950.
Musée de l'Annonciade, Saint-Tropez.
Top right: Dunoyer de Segonzac
painting at home.
Bottom left:
Henri Manguin,
Baigneuse à Cavalaire.
Oil on canvas.
Musée de l'Annonciade, Saint-Tropez.
Bottom right: view of the
Grimaud region from
the 1920s with the ruins
of the fort in the background.

ters. "We are here at the seaside, two kilometers from a little fishing village, Le Lavandou, which is not found on the map. … Saint-Clair is a plain on which some twenty houses are scattered about."[6] Maximilien Luce moved to the area and was with Cross when he died at Saint-Clair. The artist was laid to rest in the nearby cemetery of Le Lavandou. Nicolas de Staël also spent time in Le Lavandou following World War II.

Henri Manguin also had the pleasure of painting on the rocky coast of Cavalaire so exalted by Cross. In a letter to Signac, Cross wrote, "Hills of pine and cork-oak come down to gradually die out in the sea, and in passing are treated to sand of a fineness unknown on the coast of the English Channel. … Charmingly intimate spots crowd next to great magical and decorative traits. Yes, these are the two epithets that best describe the sensations I have experienced up until now."[7] In his *Baigneuse à Cavalaire* (page 84), reinventing the ancient theme of the naiad, Manguin transforms her into a modern swimmer—a theme he would often return to. The shirt and large hat

Opposite:
Henri-Edmond Cross,
Baie de Cavalaire. 1906–7.
Oil on canvas.
Musée de l'Annonciade, Saint-Tropez.

———

Dunoyer de Segonzac
in the vineyards near his home.

"We are here [...] on the sea coast, a mile or so away from a fishing village, Le Lavandou, which isn't on the map [...] Saint-Clair is a plateau on which about twenty houses are scattered [...] In the summer, the light cast profusely across everything, attracts you, shocks you, drives you to insanity [...] Here, our beaches are empty. Elegance is only found in the pine trees growing in the sand and the delicious half-moon of the shoreline. It is eternally beautiful! or terrible or frivolous, depending on the mood of the observer. The almond trees are in full bloom, as are the mimosas. You can imagine the gaiety of the landscape in which we revel under this blue sky."
Henri-Edmond Cross

Raoul Dufy,
Grand Arbre à Sainte-Maxime. 1942.
Galerie musée Raoul Dufy, Nice.

clearly indicate that tanning was not a custom of the period. The Pointe de Layat can be recognized in the background. Today, so terribly overrun with sun-seekers, it is difficult to imagine that Cavalaire was once the *Alconis Portus* of the maritime itinerary of Emperor Antoninus.

Cogolin

At the edge of the Fôret des Maures, which supplies the briar bushes indispensable for the production of its famous pipes, Cogolin has inspired the lovely landscapes of various painters, notably Marko. The young Yugoslavian Marko Celebonovitch moved to Saint-Tropez in 1925, where he met Signac along with the other artists working on the peninsula. Thanks to numerous trips back to his homeland, he encouraged many Yugoslavian artists to join him in Saint-Tropez, where he lived and worked for the rest of his life. The superb *Rue de Cogolin,* painted around 1936 and characteristic of Marko's "green period," is a fine example of the subtlety of his art. Time seems to have

A street in Grimaud
in the 1940s.

stopped for this street, which has remained unchanged since the painting was completed. All the better, since this unique region of the Golfe de Saint-Tropez, once ruled by the Moors, has an identity of its own. In fact, at the beginning of the twentieth century, whether from Cogolin, Grimaud or Sainte-Maxime (of which Dufy painted the *Grand Arbre à Sainte-Maxime*), locals were likely to simply say that they came from "the gulf."

Grimaud

In the valley of the Garde River, with its ascent to the old feudal castle, Grimaud is ideally situated to look out upon the Midi. A cultured man as well as an artist, André Dunoyer de Segonzac was seduced by the town's scenic streets and he set up his easel in front of Grimaud. In one season, he was able to capture the stormy weather that he alone sought out, as in his sumptuous *Paysage de Grimaud* (page 84), a landscape of the town painted around 1950, now hanging in the Musée de L'Annonciade.

Marko, *Rue de Cogolin.* c. 1936.
Musée de l'Annonciade, Saint-Tropez.

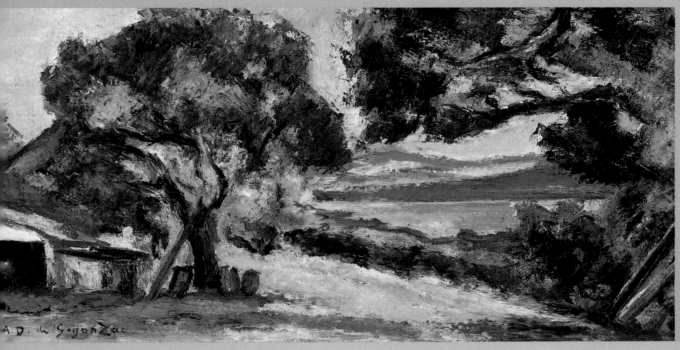

Saint-Tropez

Saint-Raphaël

A little fishing village with its traditional charm, this spot was a natural lure for artists. Seen from the citadel, a view that takes in the village clustered around its church tower and the Mediterranean, Saint-Tropez is a work of art in itself. In 1892, Paul Signac, fascinated by the light, moved to Saint-Tropez in order to develop his pointillist technique. It was while looking for a sheltered moorage for his sailboat Olympia that he discovered the village. (An enthusiastic sailor, Signac would own twenty-eight different boats during his life, including the famous *Faux-col*, baptized by Mallarmé.) To go back to the beginning of this passionate encounter, it should be remembered that Signac was introduced to sailing by the wealthy Impressionist Gustave Caillebotte, and that it was at the invitation of his friend Cross that he arrived from Marseilles, having sailed through the Canal du Midi. And thus a tiny fishing village became famous, all thanks to a sailing painter in search of an anchorage! Signac settled into an immense studio-home and repeatedly painted the

SAINT-TROPEZ

houses that lined what is now quai Jean-Jaurès. *Saint-Tropez, le quai* (page 98-9) was painted by Signac in 1899, and it is one of his most beautiful views of this village that forms the backdrop to his finest works. Employing a divisionist technique, the painting proposes a veritable ballet of sails, its movement in playful contrast to the calm of the seascape. Signac was highly influential in his role as president of the Salon des Indépendants and, following his example, a number of major painters came to the little port. First Maximilien Luce as of 1892; then the Nabis, such as Bonnard and Vuillard; then the Neo-Impressionists, including Cross and Seurat, followed by nearly all of the Fauves, and independent artists such as Kisling (*Paysage de Saint-Tropez*, page 97). The litany of names and dates is extensive, and it is important to remember that for each of these artists, Saint-Tropez—with its unique colors and light—was a revelation.

Signac first lived in a beach hut near the Plage des Graniers and then, in 1897, bought the Villa La Hune. At

Opposite: Henri Lebasque,
Port de Saint-Tropez. 1906.
Musée de l'Annonciade, Saint-Tropez.

———

Maximilien Luce,
*La Côte de la citadelle
à Saint-Tropez.* 1892.
Musée de l'Annonciade, Saint-Tropez.

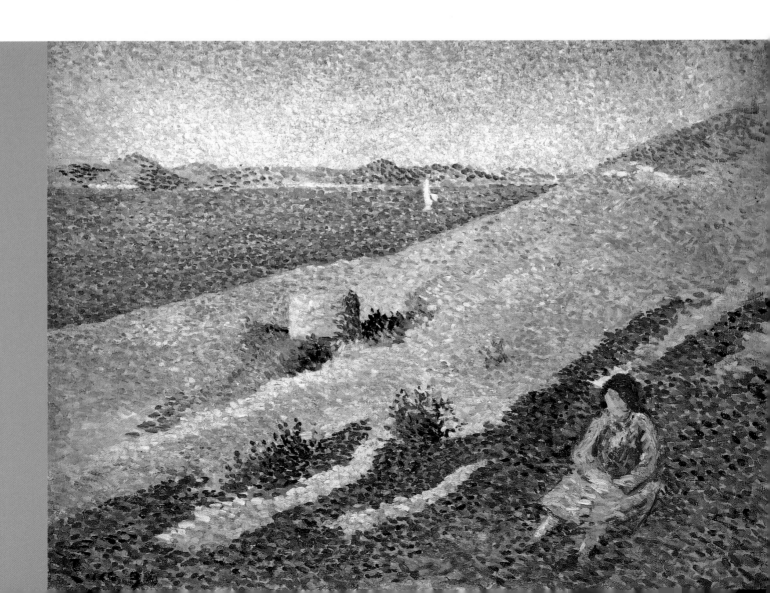

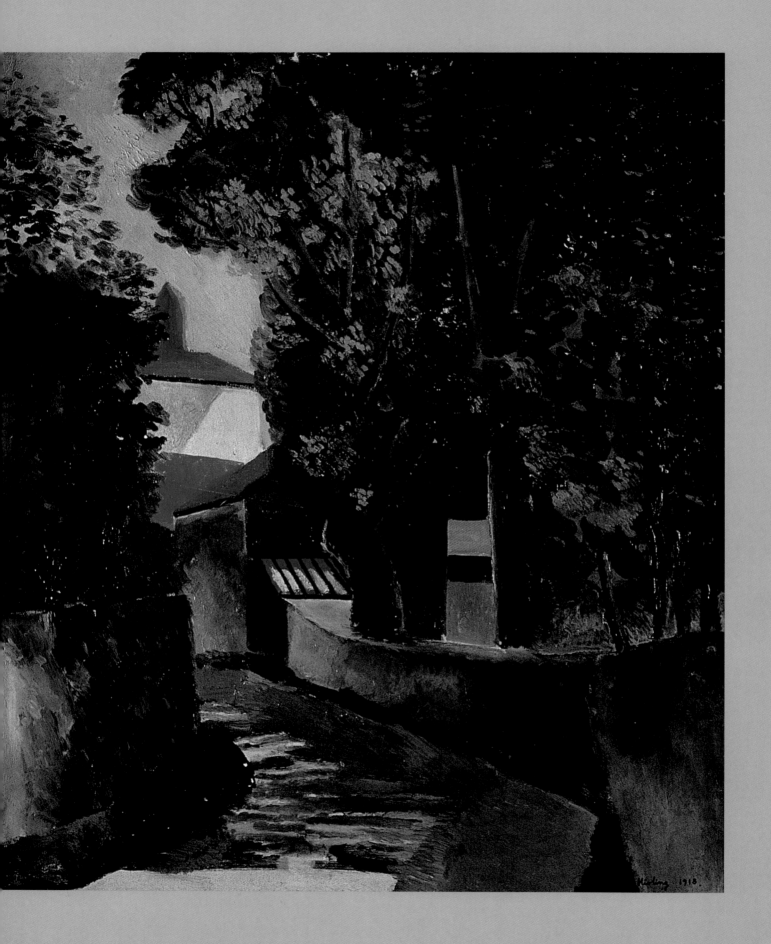

the time, those who were not good sailors arrived in Hyères by train and then managed to get to the railroad crossing at La Foux, from where a steam train traveled to Saint-Tropez in less than half an hour. Henri Matisse arrived at Signac's home in the summer of 1904—a significant visit in the history of modern art, since it was at the insistence of Signac that the artist began practicing a divisionist technique (before evolving to Fauvism). Matisse stayed at Villa La Cigale, which was loaned to him to by Signac and was located just below Villa La Hune. There Matisse confronted his work on color using the divisionist theories of Seurat, of whom Signac was a zealous advocate. He marveled at the work of Cross in which the colorful lyricism transfigures reality. Impressed by these new perspectives, it was on the Plage des Canoubiers that Matisse set to work on the sketches he would later use to paint his renowned *Luxe, calme et volupté*. The painting caused a stir at the 1905 Salon des Indépendants after which it was bought by Signac. For Dufy, the painting gave him new reasons to paint: when he contemplated the "miracle of the imagination" apparent in both the drawing and the color, realism as perceived by the Impressionists lost all its appeal.

One year after Matisse, Charles Camoin came to work in Saint-Tropez in Signac and Cross's entourage, accompanied by Manguin and Marquet. And in fact it was Marquet who was to show him the path to pure color. From then on, Camoin divided his time between his studios in Montmartre and Saint-Tropez. In 1918, he met Renoir in Cagnes who gave him a somewhat belated taste for Impressionism, which in this natural epicurean became vivid and sensual. From 1935 to 1943, Camoin moved into an apartment set up within the kitchens of the firm of Georges Grammont, an industrialist who would later make the impressive donation that forms the core of the collection in the Musée de l'Annonciade. *La Place aux Herbes à Saint-Tropez* (page 107), painted in 1905, is a recollection of Camoin's first sojourn in the company of Marquet—a trip that seems to have been particularly pleasant. The painter recounted these days to Matisse as a time spent sitting around with Marquet, waiting for the sun and rocking with laughter. In this charming painting, a diagonal separates the composition into two very formal parts: the sun to the right and the shade to the left. The interests of the study lies neither in the description of village life nor in its architecture, but rather in the play of the intensity of colors.

Taken all together, the views of Saint-Tropez painted by

Moïse Kisling,
Paysage de Saint-Tropez.
1918. Oil on canvas.
Musée des Beaux-Arts, Menton.

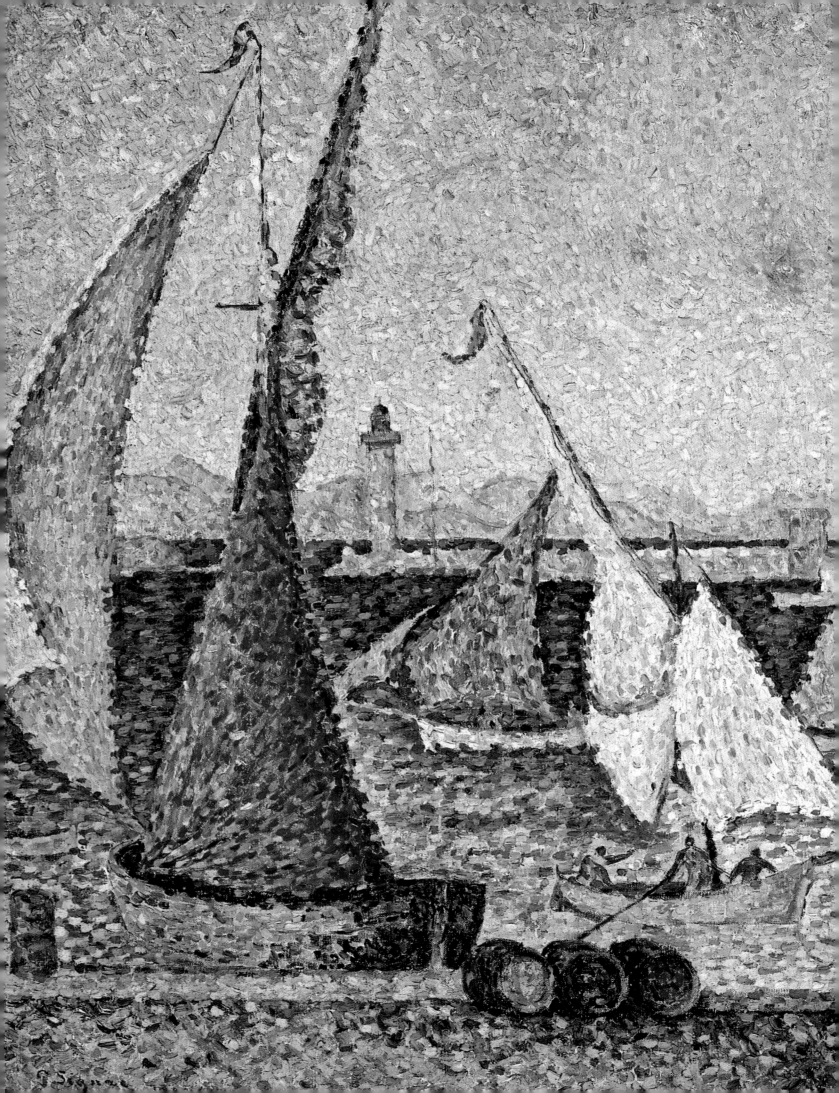

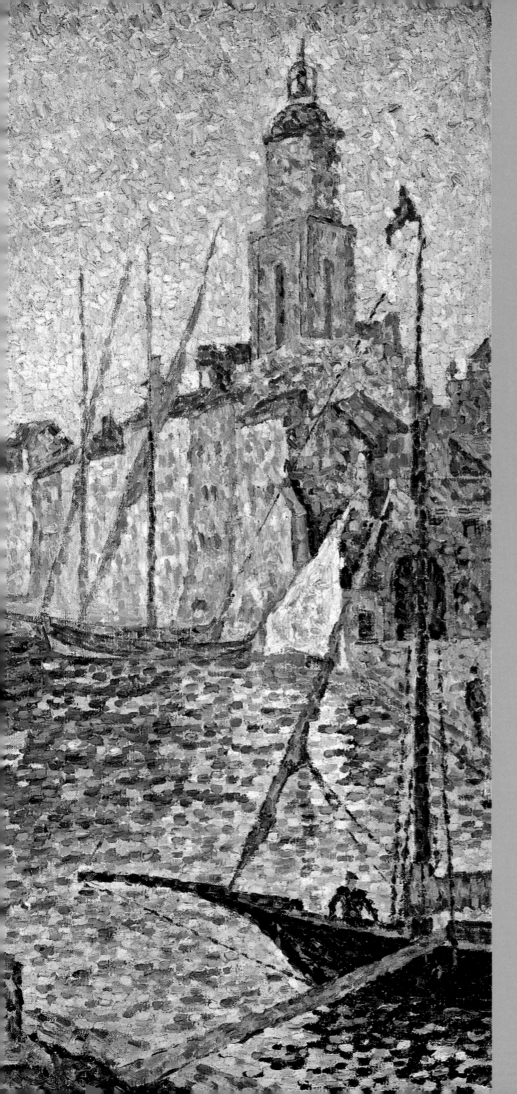

"I can see the sea so close, the mountainous chain of the Maures, and, in the distance, the islands of Hyères, so beautiful that they are called the Golden Isles. The mountain peaks draw ornamental lines on the horizon, and on the apron of the beaches . . . this fine, yellow sand sparkles in the light."
Letter from Cross to Signac, late 1891

Paul Signac,
Saint-Tropez, le quai. 1899.
Oil on canvas.
Musée de l'Annonciade, Saint-Tropez.

these artists offer a panorama of the town that, happily, can still be discovered today. In 1892, Maximilien Luce painted *La Côte de la citadelle à Saint-Tropez* (page 95): the wonder of his discovery must have been all the more striking, since the painter had spent the previous months painting the London fog. The impression of the dazzling light of the Midi is perfectly rendered through his typically neoimpressionist brushstroke, while the figure and the sailboat give a touch of detail to this radiant seascape. As if to show how great a difference there is between what endures and what disappears, twenty years later Luce would paint the same unchanged landscapes, but in a technique that was radically different from that of his younger years. Around 1925, Dufy painted the amusing *Statue du Bailli de Suffren,* a quick, lighthearted sketch of the statue of the most celebrated French sailor of the eighteenth century.

Dunoyer de Segonzac first came to Saint-Tropez in 1908, but it was not until 1925 that he bought Villa Le Maquis, near which he painted *L'Aire de blé* (page 93) that same year. He went on depicting the same wheat field at different times of day during different seasons. Dunoyer was a rare example among the various artists attracted by the peninsula, of someone who often deliberately sought out

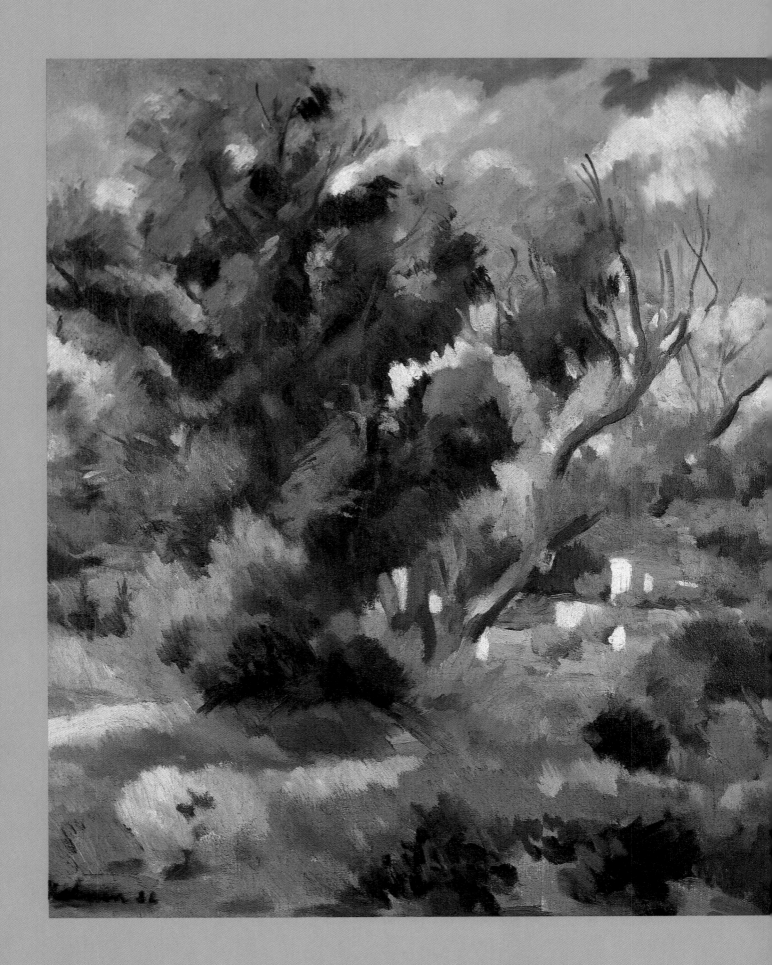

gray skies and stormy weather when painting the region.

The Alsatian Alexandre Urbain was another artist drawn by the portrayals of the countryside around the little port. In 1922, he painted a fine view of the landscape dominating the Bay of Canoubiers. Although a friend of Signac, Urbain remained faithful to Impressionism when depicting this lovely landscape. Another name not to be forgotten when recalling the Saint-Tropez of painters is Henri Lebasque. A painter of the Côte d'Azur's pleasant lifestyle, its gardens, villas and beaches, his artistic path lay between Matisse and Bonnard, as can be seen in his *Port de Saint-Tropez* (page 94), painted in 1906. The port had certainly already been painted many times by other artists, but Lebasque was fascinated by it from the moment he arrived in 1906. Here the port is pictured as shadows lengthen in the tranquillity of the setting sun. It was once again thanks to an invitation from Signac that Manguin discovered Saint-Tropez, and his villa La Demière would in its turn become a rallying point for painters. Manguin so loved Saint-Tropez that he would only leave for short periods, and it was here that he ended

Charles-Henri Person,
Sortie du port de Saint-Tropez.
Musée de l'Annonciade, Saint-Tropez.

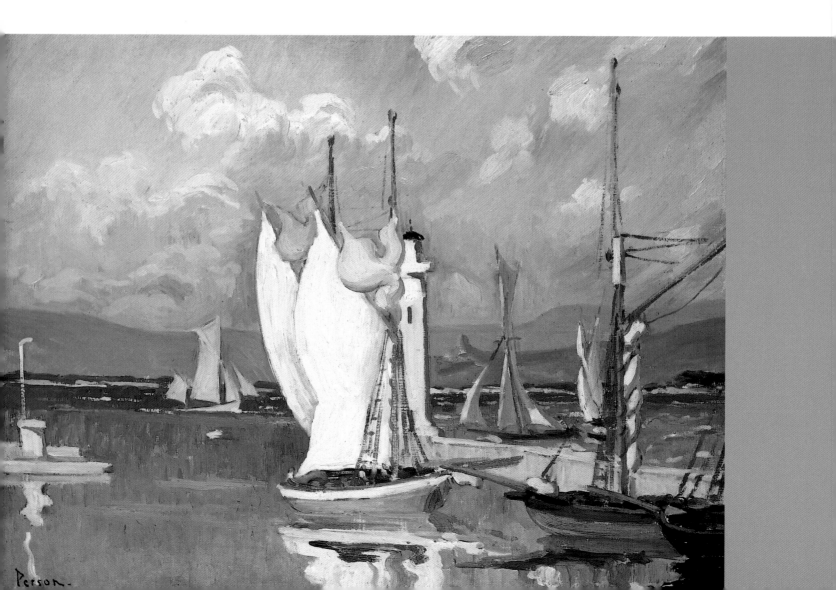

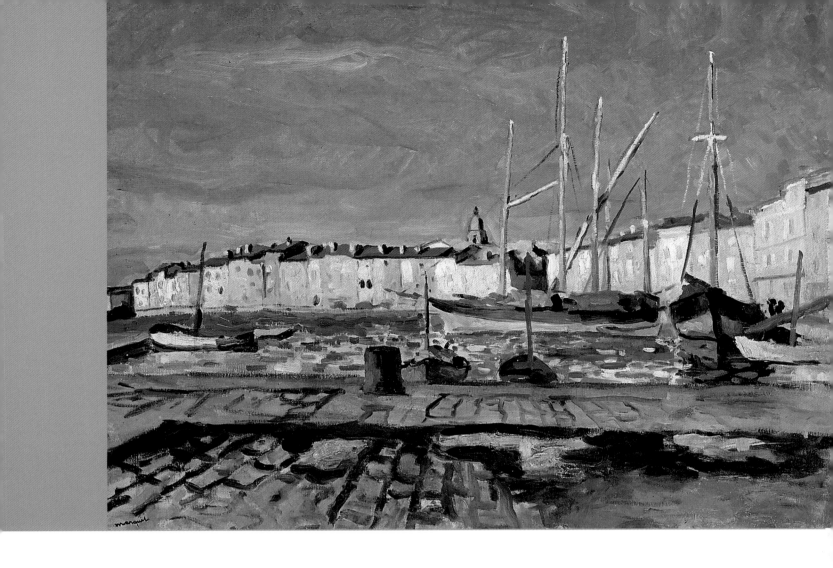

his days. In 1925, in the middle of his career as a painter, he completed the stunning *Vue sur le Golfe de Saint-Tropez,* a view of the gulf carefully composed around the church tower that occupies the center of the painting.

For his part, Marquet has left us the magnificent painting titled *Saint-Tropez, le port,* in which the strong horizontal lines and the balanced composition testify to the serenity that the artist then knew in this resort that he found so inspiring.

It was not until after World War I that Charles-Henri Person painted his *Sortie du port de Saint-Tropez.* The artist's passion for boats—which are the true subject of this painting—can be sensed in the work: here, as the wind swells the sails of the boats leaving the harbor, Person offers us a magnificent vision of a sun-filled morning on the gulf.

Sometimes in the midst of this anthology of painters and their friends, there appears a figure that seems out of place under the warm Provençal light. Such is the case of Francis Picabia, who in 1909—before promoting the Dada movement with Marcel Duchamp—painted in Saint-Tropez where he was spending his honeymoon. The influence on him of the inescapable Signac was brief but undeniable, as can be seen in the *Saint-Tropez vu de la citadelle* (page 92), executed in a resolutely neo-impressionist technique.

Albert Marquet,
Saint-Tropez, le port. 1905.
Oil on canvas.
Musée de l'Annonciade, Saint-Tropez.

The old port of Saint-Tropez
at the beginning
of the twentieth century.

Of course, Saint-Tropez did not only attract French artists. In 1910, the Russian Jean Peské moved to Bormes and spent five years there. Fascinated by the Massif des Maures, he painted it many times. Fifteen years earlier he had, however, already worked in Saint-Tropez, as can be seen in his lovely *Saint-Tropez et le phare vert* (page 108-9), dating from 1895. This picture shows an uncommon view of Saint-Tropez, painted near the old green lighthouse from the edge of the port (where today a dreary parking lot is situated). This work is one of the rare proofs of the artist's short divisionist period, inspired certainly by Signac.

At the same time as this invasion from the north by painters wanting to taste the pleasures of the Midi, local artists also regaled the colors of their art-loving land. This is notably the case of Auguste Pégurier who was born into a family with a long maritime tradition rooted on the peninsula since the sixteenth century. Of all the native Provençal painters, he was the closest to the Impressionists, but he was also well placed to watch how the avant-garde of painting evolved in this little village, one of its most

active centers. Pégurier lovingly painted the village port and its streets such as rue Allard. His *Procession à Saint-Tropez* (1907) is constructed around the opposition of areas of shadow and those bathed in light, an homage to Monet's art. The scene pictured here takes place in the morning when the façades behind the amusing statue of Bailli de Suffren, who turns to face the mistral wind, are still in the shade. Thus, in Pégurier, Saint-Tropez had a savior of its local pride, but while he was in a privileged position to witness the aesthetic revolution taking place in the town, he took no real part in it himself.

Carlos-Reymond, a Parisian, also owed a debt to Monet who encouraged him to begin painting at the age of sixteen. Carlos-Reymond moved to Saint-Tropez in 1903, where he married the daughter of Henri Lebasque and became an initiate of Neo-Impressionism thanks to Signac. His serene *Campagne à Saint-Tropez* (page 100), painted at dawn, is a unique reminder of the countryside near the village, an area now overrun by urban sprawl. The panoramic view is painted from the lower slopes of the hills of the citadel; the Chapelle du Couvent can be recognized in the background.

From the end of the nineteenth century up until the First World War, Saint-Tropez was the place where new tech-

Auguste Pégurier,
La Procession à Saint-Tropez. 1907.
Oil on canvas.
Musée de l'Annonciade, Saint-Tropez.

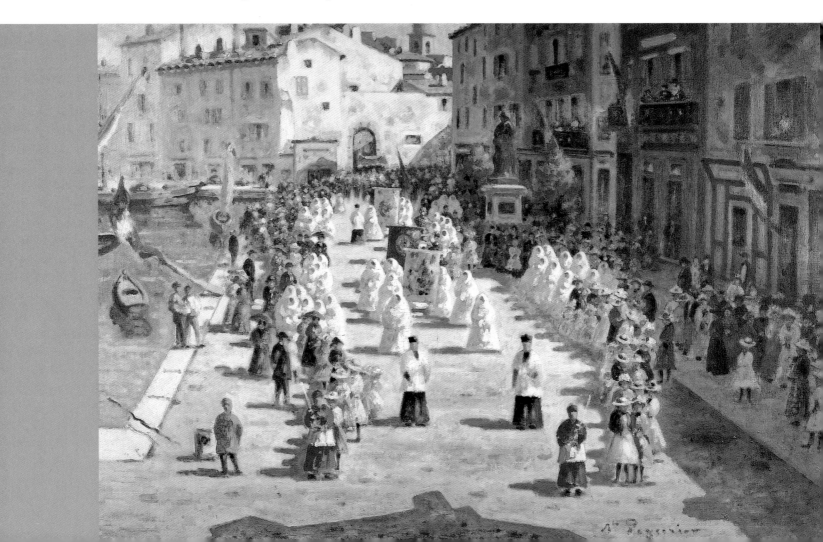

niques of modern painting were developed. The situation changed after the war, however, with most of the major painters who remained choosing to pursue a more decorative and less avant-garde style of painting. At the same time, the ever-growing number of vacationers sounded the death knell for the tranquillity of painters. The great allure of Saint-Tropez had been relegated to history. It was in 1955 that the architect Louis Süe renovated the sixteenth-century chapel of Notre-Dame-de-l'Annonciade in order to exhibit the modern paintings bequeathed by Georges Grammont, and thus the setting was found for displaying the sun-filled memory of all these artists who had managed to paint a new Mediterranean Arcadia.

Saint-Tropez at the end of the nineteenth century.

——

Opposite: Charles Camoin, *La Place aux Herbes à Saint-Tropez.* 1905. Musée de l'Annonciade, Saint-Tropez.

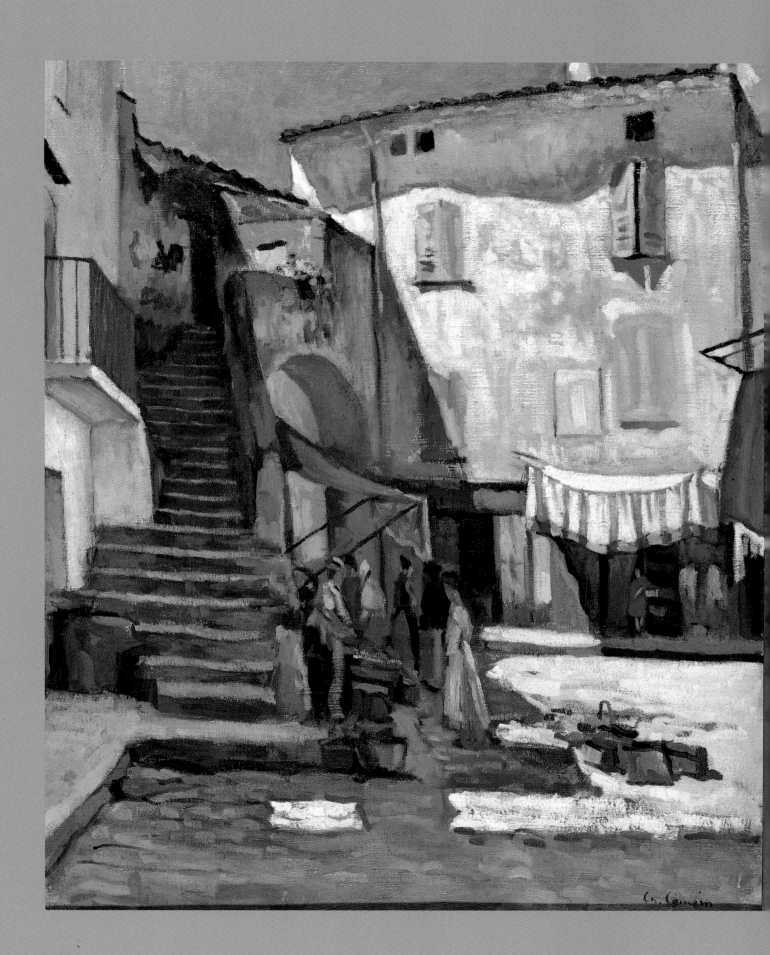

"The long red coast runs into the blue water that makes it look violet. The coast is bizarre, eerie, beautiful, with peaks and innumerable bays, capricious and charming cliffs, a thousand fantasies admired from the mountain. On its sides, pine forests climb up to the granite peaks that resemble chateaux, towns, armies of rocks chasing each other. And at the foot of the mountain, the sea is so limpid that one can distinguish the patches of sand and the patches of vegetation."
Guy de Maupassant on the Esterel coast

Jean Peské, *Saint-Tropez et le phare vert*. 1895. Musée de l'Annonciade, Saint-Tropez.

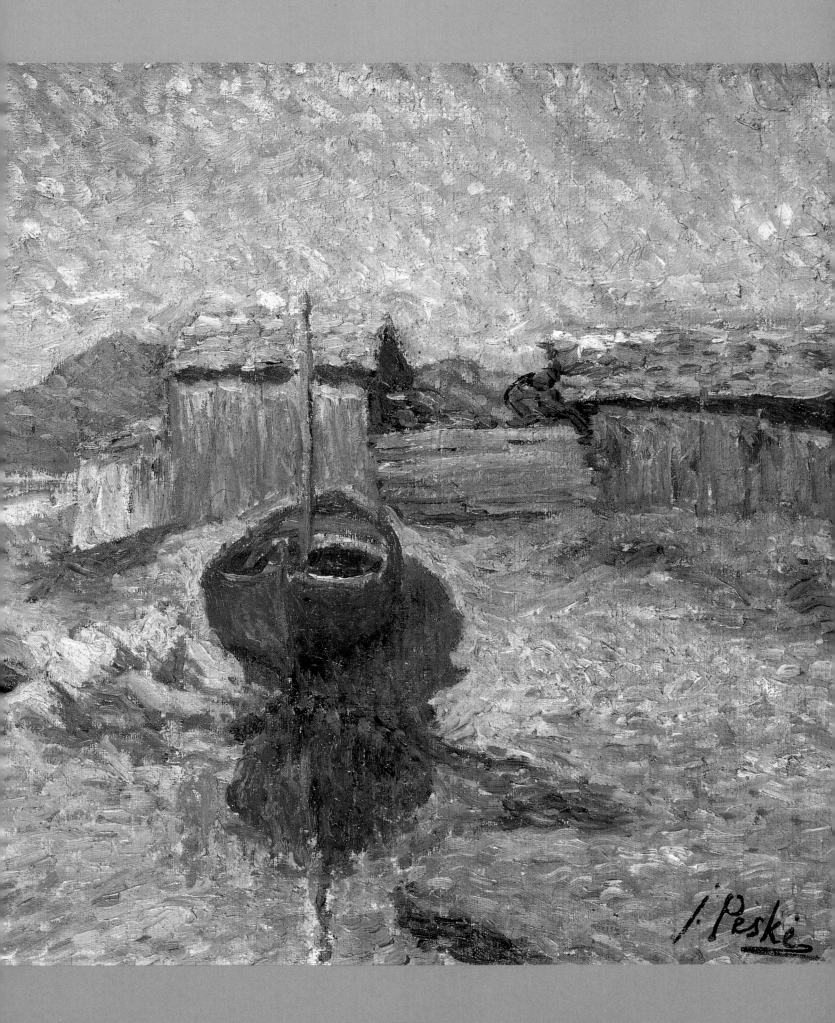

Saint-Raphaël

Here too, the local painters had preceded Signac and his friends in observing the exceptional views of the Esterel. Pierre Decoréis delighted in painting this scenery and provides a precious record of it, especially since today the landscape has drastically changed. In his *Pin à Saint-Raphaël,* an obsolete silhouette of a shelter for the Côte

Pierre Decoréis,
Pin à Saint-Raphaël. 1877.
Oil on canvas.
Musée du Vieux Toulon, Toulon.

d'Azur train can be seen. This local train took a full five hours to cover the ninety miles of the Var line, traveling from Toulon to Saint-Raphaël. A traditional image in a land that certainly had no lack of them, the steam engine that puffed along carrying the first tourists through this enchanted countryside served as a model for a number of local painters. However, it is the majestic umbrella pine— emblematic of Provence—that is the most important subject of the composition.

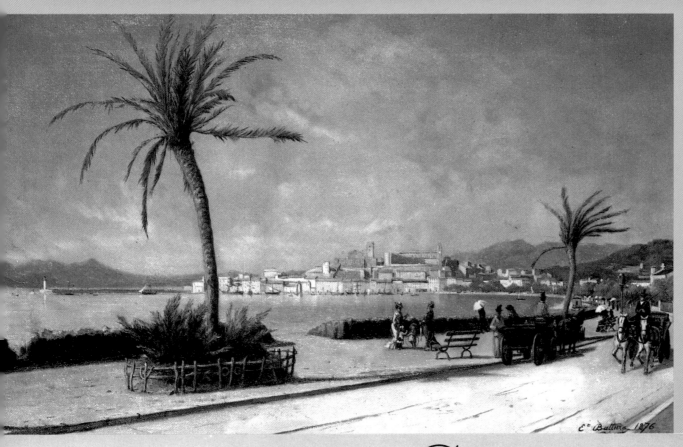

Cannes

Le Cannet

Mougins

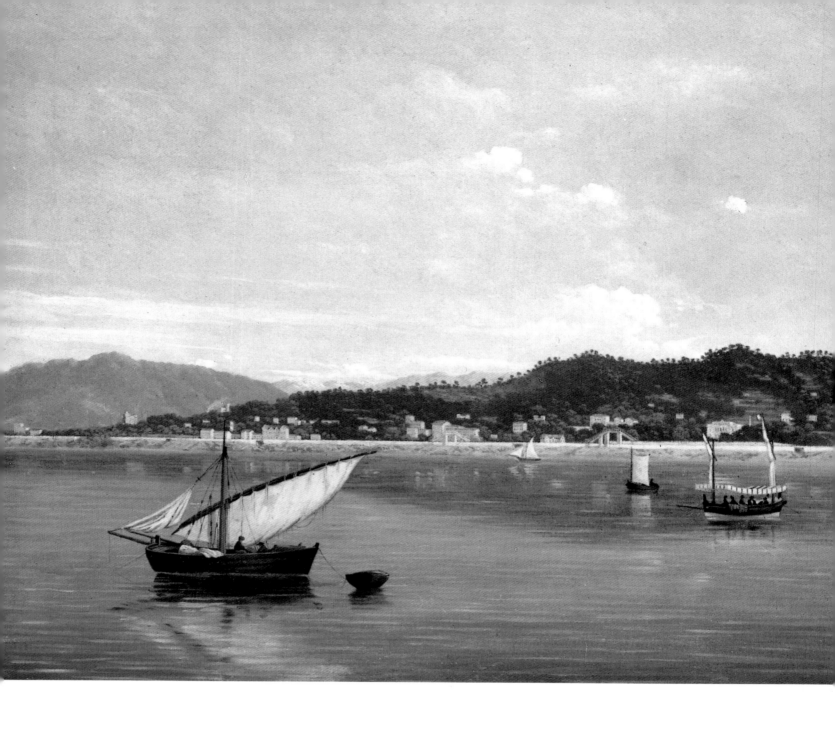

Preceding pages, top right:
Ernest Buttura, *La Croisette en 1876*.
Oil on canvas.
Musée de la Castre, Cannes.
Bottom left: Pierre Bonnard in his
garden. Photograph by Edouard
Vuillard, Musée d'Orsay, Paris.
Bottom right:
View of the port
in the 1950s.

From the end of the Second Empire until World
War I, it is possible to speak of a Cannes School,
but it is one linked more to the presence of visiting
artists than to any local tradition. Orientalists and amateur
painters quite naturally found not only the scenery of their
dreams here, but also the ideal clientele.

Among the many picturesque sites of Cannes, such as Le
Suquet and the château de la Napoule, La Croisette has
probably captivated the greatest number of painters, both
well-known ones on short stays and local dilettantes. In *La
Croisette en 1876* (page 113), the young Ernest Buttura
painted the famous esplanade, created in 1868. La
Croisette owes its current name to a small antique cross
that stands at the extreme east of the bay, but up until the

Joseph Contini, *Cannes en 1865*.
Oil on canvas.
Musée de la Castre, Cannes.

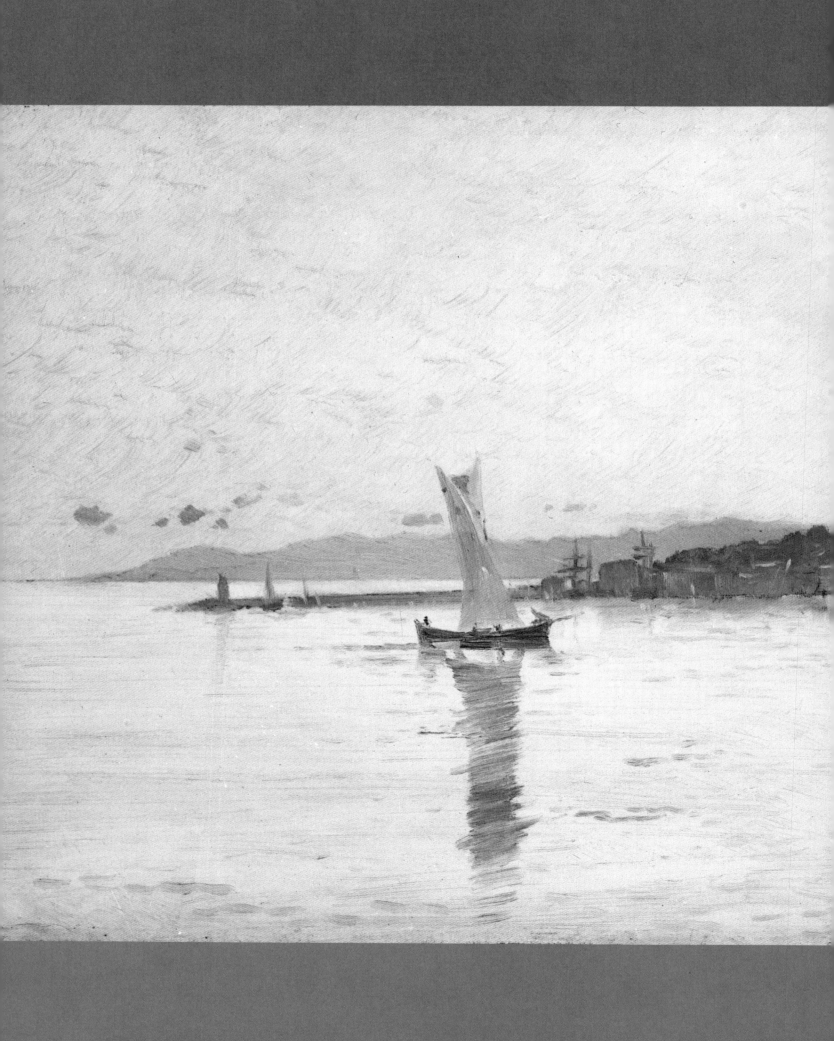

"As Delacroix wrote in his diary, 'One never paints violently enough.' In the light experienced in the South of France, everything sparkles and the whole painting vibrates. Take your picture to Paris: the blues turn to gray. Seen from afar, those blues also turn to gray. Therefore one thing is necessary in painting: heightening the tone."
Pierre Bonnard

Félix Pille, *Le Suquet vu de la Croisette*. Oil on canvas. Musée de la Castre, Cannes.

Pierre Bonnard,
Coin de la salle à manger.
1932. Oil on canvas.
Musée national d'art moderne, Paris.

formation of the Third Republic in 1871, this route was known as the boulevard de l'Impératrice. Unlike Napoleon's empire, the palm trees have remained valiantly in place. Planted the year that the empire fell, and naturally taller now than in Buttura's painting, they nearly succumbed to fierce frosts in February 1985. The beach is smaller in the painting than it is today. During the 1960s, some 150,000 square yards of sand was imported and the beach artificially broadened. It should be added that during this period of redevelopment, the esplanade itself was leveled off with debris from the railroad then under construction. Buttura's view is from in front of the Hôtel Gonnat which allowed him to take in both La Croisette and Le Suquet. The general spirit of the work is highly characteristic of the Cannes School and parallels the idyllic image conveyed by posters and lithographs—a glassy sea, an azure sky, an enchanting landscape. Amid this beauty mingles an idle crowd, brought up in the secure, unruffled world of the pre-1914 ruling class. Buttura him-

self knew this world well, as his father had been the royal family doctor until 1848.

Sign painter and decorator, Félix Pille painted *Le Suquet vu de la Croisette* (page 116-7). In his rendition of the lively Le Suquet quarter once inhabited by fishermen, we find a typical Provençal village crowned by an ancient tower. Built at the initiative of the abbots of Lérins, the purpose was to protect the monks from pirate attacks. Nevertheless, Pille's style is a far cry from that of Buttura, both in its wide and rapid brushstroke and its muted, delicate tones. Here the concern with details which is omnipresent in the works of the Cannes School, gives preference to a rendering of atmosphere. Such paintings met with quick success among the vacationers and, rather than place them in someone else's art gallery, Pille exhibited his works in his own boutique "Cannes Artistique." Although the competition was fierce, there was no lack of customers, and a multitude of lesser but still talented painters including Joseph Contini, who has left us *Cannes en 1865* (page 114-5), were active. Several foreign painters, attracted by the climate and the pleasant lifestyle, also made a habit of spending time in Cannes. The Swiss artist Gustave Jaulmes (1873–1959) frequently stayed on the Côte d'Azur and painted a number of murals in Grasse, Cannes and, most notably, Beaulieu, where he decorated the famous Grecian-style Villa Kérylos. Also a painter of landscapes and marine scenes, he often worked from the port and jetty of Cannes, making the most of the changing light, as can be seen in his sunset, *Coucher de soleil, Cannes,* from 1930. Concerned with the structure of his compositions, Jaulmes must have especially loved the pure geometry seen from this vantage point.

Le Cannet

Pierre Bonnard's first visit to the Midi brought him to Manguin's home in Saint-Tropez. Overwhelmed, he declared, "I have had an experience akin to the thousand and one nights: the sea, the yellow walls, the reflections which are as colored as the light effects...."[8] Yet Manguin was not the only artist whom Bonnard liked to visit in Provence. He also regularly visited Renoir in Cagnes until the latter's death in 1919. Beginning in 1910, Bonnard would rent a villa in the Midi every winter, most often in Grasse. In 1926, a year after his marriage to Marthe, his

longstanding companion and model, he bought a villa in Le Cannet and soon enlarged his property by acquiring neighboring land. The house, which he baptized Le Bosquet, opened on to a splendid landscape that had a view of the sea, the roofs of Le Cannet and the distant Esterel mountains. Bonnard enjoyed his lush rambling garden, untamed by the hand of man. From the time he took ownership of this little paradise, he preferred to stay here, spending only two months a year in Paris. It was during this period that he undertook a series of large landscapes of strongly contrasting colors and clearly demarcated planes. Bonnard was in the habit of making numerous sketches before embarking on such major works. His great-nephew, Antoine Terrasse described how Bonnard, who had always looked upon the colorful explosion of Fauve painting with a certain circumspection, let himself be carried away by the light of the Midi and gave it the leading role in his painting. He then became much more sensitive to the inexhaustible variety of reflections, trails and accidents that light introduces into color. Bonnard even said, "In the South of France, everything sparkles and the whole painting vibrates. Take your pictures to Paris: the blues become gray."

Long before Renoir and Bonnard, other illustrious vacationers such as the novelist Prosper Mérimée and the actress Rachel, enjoyed the lifestyle of Le Cannet. Following regular stays in Saint-Tropez and Sainte-Maxime, in 1924 Lebasque moved near to Bonnard in Le Cannet permanently.

Mougins

Both the climate and the perfect location of Mougins attracted an initial group of artists that was later followed by such important artists as Cocteau, Man Ray and Fernand Léger, all of whom came to work in the calm surroundings of this beautiful town overlooking the bay of Cannes. During his last years, Pablo Picasso adopted the charming hill as home, moving into a house near the chapel of Notre-Dame-de-Vie, an impressive edifice built in the twelfth century on the site of an ancient temple dedicated to the goddess Diana. The chapel, adorned with two rows of cypress trees, was an inspiration to numerous painters including Winston Churchill a keen amateur painter. Near the church is another important spot—the hotel Les Muscadins, where one fine morning Picasso set

Pierre Bonnard,
L'atelier au mimosa. 1939.
Oil on canvas.
Musée national d'art moderne, Paris.

down his bags and fell in love with Mougins. The story goes that one particularly inspired night, Picasso covered the walls of his room with frescos. Unfortunately, the artist's fame had not yet reached the ears of the hotel owner who forced the master to repair the "damage." Images of the painter in action can been seen a few yards' walk from the hotel in the Musée de la Photographie, which holds a collection of photos of Picasso taken by the greatest photographers of his day.

In 1925, having been an inexhaustible traveler, Francis Picabia finally settled for twenty years in Mougins. Here he would develop his transparent paintings—where the outlines of different subjects are superimposed, and then later on, his nudes.

From Grasse to Vence

Grasse

Vence

Biot

Cagnes-sur-Mer

Saint-Paul

Grasse

Although he was born in Grasse, the only time that Jean-Honoré Fragonard actually lived there was from February 1790 to March 1791, while fleeing the Revolution. Nonetheless, when he decorated the monumental staircase in his cousin's house in Grasse (now the Musée Fragonard) with a trompe l'œil, he was careful to include the Masonic and patriotic motifs that were in the spirit of the time.

Like Fragonard before them, a number of painters found in Grasse a refuge in difficult times. Roger de la Fresnaye (1885–1925), whose health was too fragile for the harsh conditions fighting on the front in World War I, contracted tuberculosis in 1918 and moved to Grasse. In the few years before his death, his painting evolved toward an almost Ingres-like classicism. Then during the Second World War, Alberto Magnelli lived in Grasse, where he met Jean Arp and Sonia Delaunay.

Vence

The twentieth century has endowed this pretty village with all forms of art. The Musée Carzou is housed in a seventeenth-century chateau in front of which still stands a tree that was planted during the visit by François I in 1538. As for Vence's religious monuments, they also stand as monuments to modern art and the artists who decorated them. Chagall, who moved to Vence in 1950, adorned the cathedral's baptistery with the mosaic *Moïse sauveé des eaux*. During the period between 1948 and 1951, Matisse designed and decorated the celebrated Chapelle du Rosaire, where the light pours through the tall stained-glass window on to murals composed of large drawings of black lines on white ceramics. Sunlight also floods the chapel's two naves—one for lay people and another smaller one reserved for the religious community. Matisse created this masterpiece (he himself considered it as such) for the Dominican nuns who had nursed him during the war. The ensemble represents the synthesis of his entire work. Matisse also painted in Vence, and *La Liseuese à la table jaune* (page 126-7) is just one of the masterpieces he created there.

Along with these prestigious names, another fine artist must also be mentioned regarding his work in Vence. Raoul Dufy first came to the Midi in 1919, painting on several occasions in Hyères and Sainte-Maxime. But it was Nice, and even more so, Vence that provided the subjects for many

Preceding pages, left: Henri Matisse, Decoration of the Chapelle du Rosaire, between 1948 and 1951. Top right: Raoul Dufy, *Paysage de Vence*. 1919–20. Galerie Musée Raoul Dufy, Nice. Bottom left: photograph of Pierre-Auguste Renoir. Musée Picasso, Paris. Bottom right: view of Saint-Paul-de-Vence during the 1950s.

Opposite: Marc Chagall, *Moïse sauvée des eaux*. Mosaic in the Cathedral baptistery, Vence.

Henri Matisse 4/440

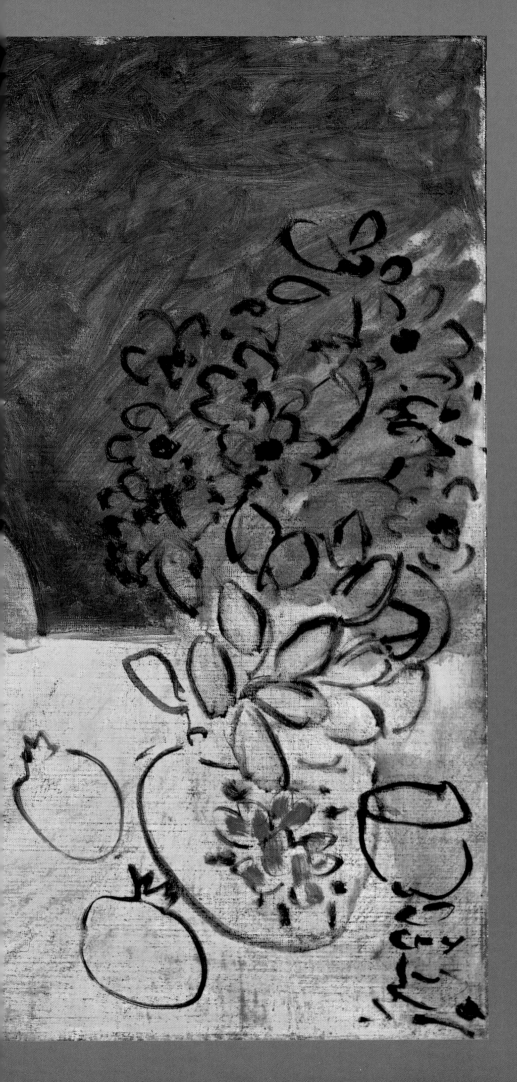

"Look at the light that falls
on the olive trees, bright
as diamonds. Now pink, now blue.
And the sky coming through.
It's enough to drive one mad!
And the mountains that float past
with the clouds. It's a background
straight out of Watteau."
Renoir

Henri Matisse,
La Liseuse à la table jaune. 1944.
Oil on canvas. Musée Matisse, Nice.

of his works. It was in Vence that Dufy developed the style that he would adhere to until the end of his career: lively, baroque outlines drawn in an expressive freehand are superimposed on arbitrarily defined areas of pure color, with line and color acting independently. The *Paysage de Vence* (page 123) is characteristic of the painter's evolution, demonstrating in particular his adept and innovative use of black.

Biot

Joan Miró.
Selfportrait. 1919.
Oil on canvas.
Musée Picasso, Paris.

———

Opposite:
Fernand Léger,
L'Enfant à l'oiseau.
Ceramic.
Musée Fernand Léger, Biot.

Pottery making has been recorded in Biot ever since the fourteenth century, but it undoubtedly began even earlier. It was in the eighteenth century, after the War of the Spanish Succession had destroyed its agriculture, that Biot developed pottery as an industry. Then, following World War II, Eloi Monod, a ceramist from the Sèvres School, developed the famous Biot "bubble glass" (bicarbonate of soda is sprinkled on the glass as it is being heated, creating

F. Leger
53

tiny bubbles). In 1949, Fernand Léger began experimenting in Biot with techniques for making ceramics, mosaics and stained-glass windows. He used the know-how of local craftsmen to create original works, which expressed his concern for monumental art, contrast and color. The Musée National Fernand Léger in Biot is devoted to works spanning the artist's prodigious career.

Cagnes-sur-Mer

Rather early on, the countryside around Cagnes attracted such painters as Pierre Auguste Renoir, who came here looking for relief from his arthritis. He bought an olive grove called Les Collettes and built a house where he lived from 1908 until his death in 1919. The house was made into a museum in the 1960s, and paintings, including the landscape *Paysage aux Collettes,* can now be admired, along with many of his personal effects, at the very site where they were painted. It was here that Renoir often entertained friends, including Monet and the well-known art dealers Vollard and Durand-Ruel. Young women from the village

Pierre Auguste Renoir's studio
in Cagnes-sur-Mer,
which is now a museum.

———

Opposite:
Pierre Auguste Renoir,
Paysage aux Collettes. 1915.
Musée Renoir, Nice.

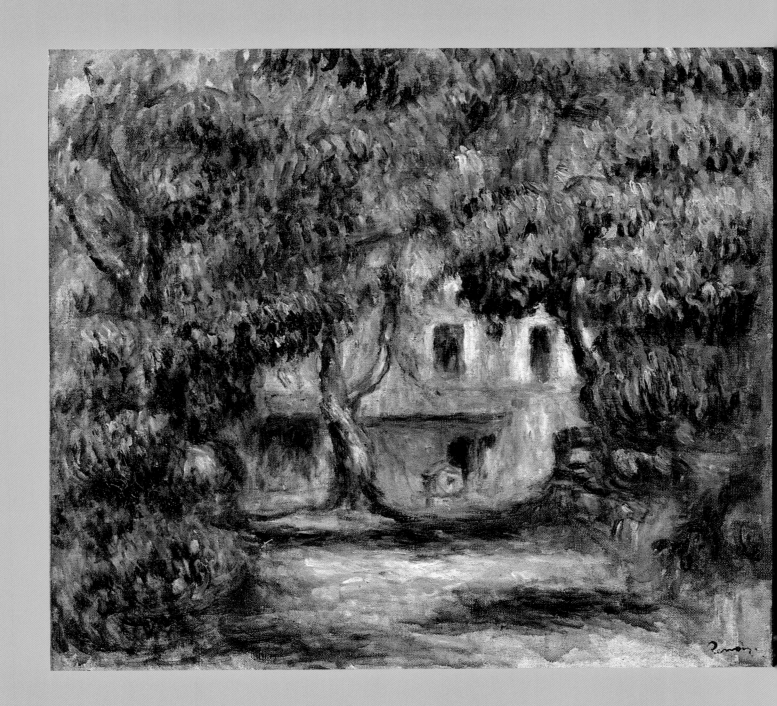

of Cagnes were employed both as maids and models. Within the warm light of the Midi, tucked in a corner of paradise, Renoir's palette became tinted in red. When Camoin moved to Saint-Tropez in 1918, he would often visit Les Collettes, acquiring from Renoir a somewhat belated taste for Impressionism. Under Camoin's hand, it became colorful and lush. In addition to paintings by

Renoir, the Musée Renoir also contains a moving bronze of the artist as he paints. It is the work of the Catalan sculptor Guino, who helped Renoir continue his sculptural work when he became crippled by arthritis.

Saint-Paul

Saint-Paul-de-Vence, a fine example of a medieval hill village, first became fashionable in the 1920s when artists such as Soutine and Modigliani thanked the owner of the Colombe d'Or inn for his hospitality by offering him works of art. A veritable museum, the inn soon became a meeting place for celebrities, which it still remains today. Marc Chagall, who lived in Saint-Paul from 1949, lies in its cemetery in the shade of cypress trees. Nearby, each year, some 250,000 visitors discover the Fondation Maeght. This modern art museum located in an exceptionally verdant setting is a unique example of a European private foundation. Braque was enthusiastically involved in its creation, but passed away before the building's inauguration by André Malraux. Its architecture was specifically conceived to present modern and contemporary art in all of its forms. Artists worked closely with the Catalan architect Josep-Lluis Sert and created monumental works that were often integrated either into the landscape or the building itself. Two such works must be mentioned in particular: Chagall's mosaic *Les Amoureux* and Miró's painting *Le Chant de la Prairie,* both created in 1964.

Opposite:
Marc Chagall,
Les Amoureux. 1964–5.
Mosaic. Fondation Maeght,
Saint-Paul-de-Vence.

Joan Miró,
Le Chant de la Prairie. 1964.
Oil on canvas. Fondation Maeght,
Saint-Paul-de-Vence.

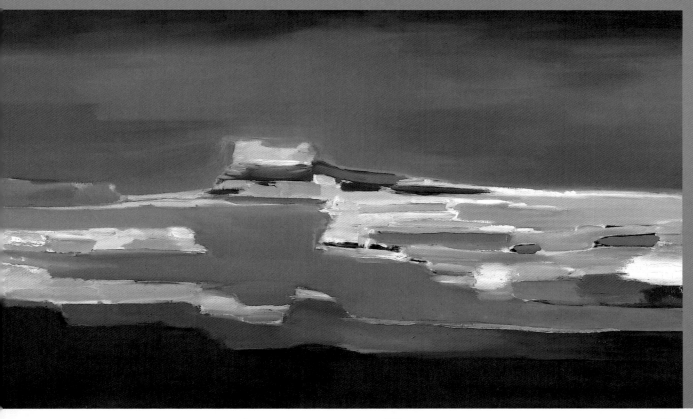

Antibes and Juan-les-Pins

Antibes
─────
Juan-les-Pins
─────
Vallauris
─────

Antibes

Eugène Boudin first visited the Midi in 1885, from which time he spent each winter there for health reasons. While the discovery of this landscape—not yet called the Côte d'Azur—was accidental, the emotional impact it had on the artist was very real. So much so, in fact, that he found all painting sad and dull next to the splendors of light in the Midi. For Boudin, the dazzling light made the place gay and

cheerful even in winter. To paint *Le Cap d'Antibes et L'Estérel*, Boudin set up his easel on the west coast of Cap d'Antibes, and while the foothills of the Esterel can be seen in the distance, the Iles de Lérins, Cannes and Golfe-Juan appear nearer. Although it is still protected from the commotion of the rest of the Côte d'Azur, today the peninsula separating Juan-les-Pins from Antibes, with its grand residences, has a very different atmosphere than the untamed place where Boudin painted. Boudin's choice for depicting the sky, almost nothing like the colors expected from this landscape,

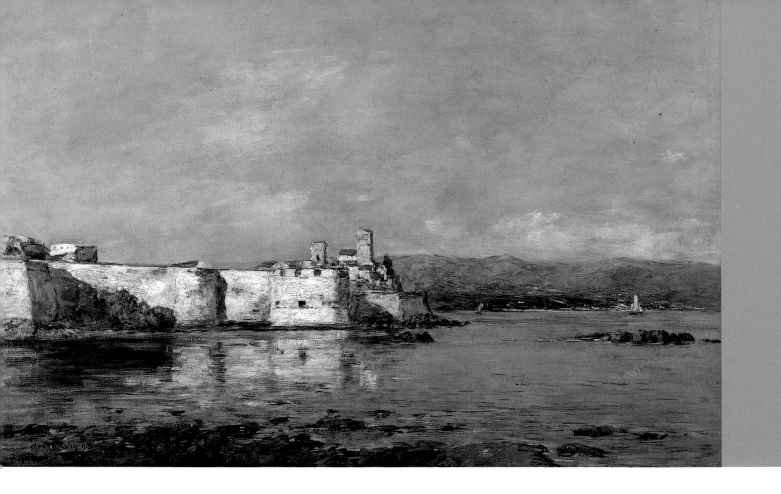

Eugène Boudin,
Vue d'Antibes, les remparts...
1893. Oil on canvas.
Musée des Beaux-Arts,
Nice.

is quite surprising, but the painter from Normandy remained true to the shades that he made his own and for which Baudelaire dubbed him the "master of skies." In addition to the exceptional atmosphere painted in a monochrome of pearly gray tones, Boudin's includes, as in many of his paintings, small figures that play a role that is more than simply decorative.

In a radically different aesthetic, Picasso's presence has forever been etched into the cultural and emotional memory of the Côte d'Azur. Just like the periods he spent in Vallauris and Mougins, his time in Antibes was essential. It is thanks to Picasso that the old Provençal city has become a center of contemporary art. Indeed, Antibes had much to please the artist: a medieval city with a Provençal market and a sixteenth-century chateau between the ramparts and the sea. Once an ancient Roman *castrum*, then an episcopal residence where the princes of Monaco lived from the fourteenth through the seventeenth centuries, the Château Grimaldi entered into the modern era in 1946, when its curator Dor de la Souchère (who had saved the building from ruin) suggested that Picasso set up his studio there. When Picasso needed materials during his stay at the chateau, he often painted over canvases kept in storage—as the modern indiscretion of X rays have shown. This, along with the techniques and unusual material that he used (plywood, fibrocement, boat paint), are proof both of post-war shortages, and of the

artist's taste for experimentation. The paintings that came out of this period testify to Picasso's joy of being alive in a newly liberated land. A grateful Picasso later gave the chateau's museum (established in 1928) the major part of the works he had created there, thus making it the first museum consecrated to his works—before those in Paris and Barcelona. His gift notably included *La Joie de Vivre* (page 142-3, rediscovered later by his companion Françoise Gilot), and the twenty-five paintings that form the *Suite d'Antipolis*. Here, themes from classical mythology are reinvented in a Mediterranean context. These are presented in their native light, along with a large group of preparatory drawings for the series. One of the rare examples of a fresco painted by the artist, *Clefs d'Antibes,* is also on exhibit. The "Keys to Antibes" might have signified for Picasso the affection of the woman he loved, the warmth of precious friendships and the beauty of a light that inspired in him an Edenic mythology, which cen-

View of Antibes from
the ramparts during the 1930s.

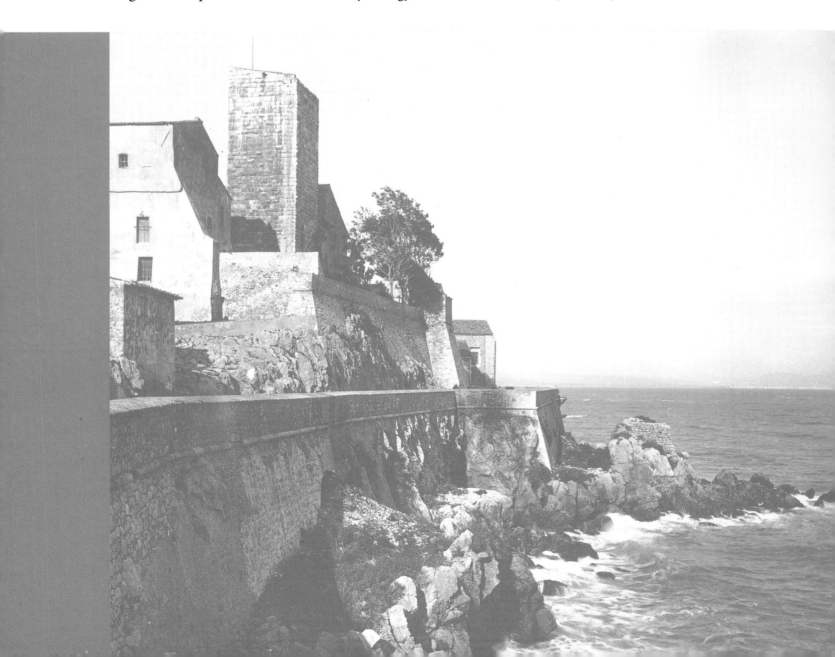

tered around woman as an incarnation of grace and *joie de vivre*.

It would be impossible to speak of Antibes without mentioning the handsome aristocratic figure of Russian-born Nicolas de Staël who moved here in 1954. Continuing the "pilgrimage" to the Château Grimaldi, in Picasso's former studio also hang a dozen of de Staël's paintings, including *Fort Carré d'Antibes* (page 135) and *Le Grand Concert* (page 137)—the artist's last work. Unfortunately, de Staël would not live to see the Fort Carré restored—physical exhaustion and mental depression led him to commit suicide in 1955. He left behind a catalogue of nearly a thousand paintings.

Like Nicolas de Staël, Hans Hartung (1904–89) also died in Antibes, where he painted hundreds of his abstract canvases of vibrant colors with their web-like striations.

Juan-les-Pins

Built along the gulf, the resort of Juan-les-Pins was established by the American millionaire Frank Jay Gould who, from the 1920s, brought great jazz musicians here to play at parties which went on till dawn. It was also in the 1920s that Picasso discovered the place. Fernand Léger was not only drawn to the town by his admiration for Cézanne, which began in the first years of the century, but also by his love of color and of the sun, which inexorably drew him to the Midi. He bought a country house named Saint-André shortly before his death in 1955, and the lovely museum built on the land was adapted to integrate two already existing works: a stained-glass window over thirty feet tall, and a huge mosaic of over four thousand square feet (originally planned for the Hanover Stadium) that stretches across the façade.

Vallauris

Ceramic plate by
Pablo Picasso.
Musée Picasso, Vallauris.

After his stay in Antibes, Picasso spent from 1948 to 1955 living in Vallauris at Villa Galoise with his new companion Françoise Gilot. In the 1950s, Picasso was almost solely responsible for reviving the town's ceramics industry, which had been established by Italian artisans in the sixteenth century. It was in 1946, following a visit to an annual potters' exhibition and after meeting Suzanne and Georges Ramié, owners of the Atelier Madoura, that the painter—always curious about new techniques—became interested in ceramics. This craft offered him new outlets for his creativ-

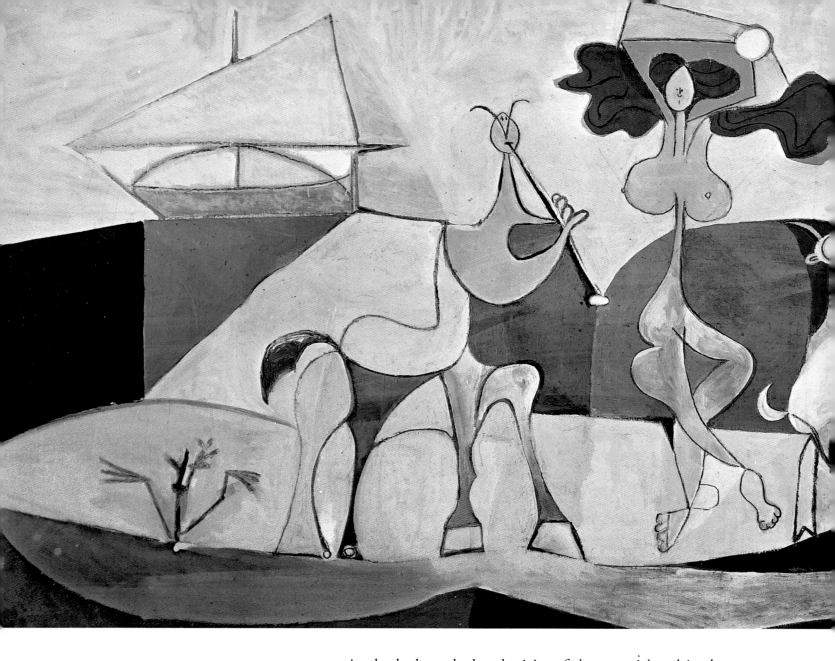

ity, both through the plasticity of the material and in the vivid colors of fired enamel. Over a span of twenty years, Picasso completed some four thousand works, most often employing unorthodox methods and using the most unlikely materials: pouring earth as if it were bronze, inventing a white clay that was not enameled and, in his studio on rue de Fournas, creating numerous sculptures using found objects. In addition to these activities, he also worked in the Ramiés' Atelier Madoura, where he became interested in yet another new technique—linocut, which he used to produce posters for ceramics exhibitions and horse races. Picasso so loved Vallauris that from 1952 to 1954 he executed an immense painting on wood which decorates the crypt of the chapel in the former priory of the abbots of Lérins. *La Guerre et la Paix* (page 134) is painted in an allegorical style that recurs in Picasso's work. After *Guernica* (1937) and *Massacre en Corée* (1951), this masterpiece represents the final demonstration of his commitment to peace. *La Paix* was inspired by the peaceful family life

Pablo Picasso,
La Joie de Vivre. 1946.
Musée Picasso,
Château Grimaldi, Antibes.

that Picasso was living at the time. And yet he chose to represent the family in the picture leading its idyllic life under the figure of a tightrope-walker, as if to express the fragility of happiness. Picasso's mark can be found everywhere in Vallauris. Ambling down the street in the direction of the church will bring you to *L'Homme au Mouton*, one of Picasso's rare statues to be found in a public space. The artist offered the statue to the town in 1949 in thanks for the warm welcome he had been given.

On exhibit in the Musée Municipal is the collection of works donated by Alberto Magnelli who lived nearby. A pioneer of abstract art, Magnelli was creating his first abstract paintings when he met Picasso in 1915. World War II had brought him to the region, notably to Grasse, and following the war he became one of the great masters of abstract art in France and Europe. The collection, which he put together himself, presents his work chronologically, beginning with the early figurative paintings, and continuing through the great abstract works painted at the end of his life.

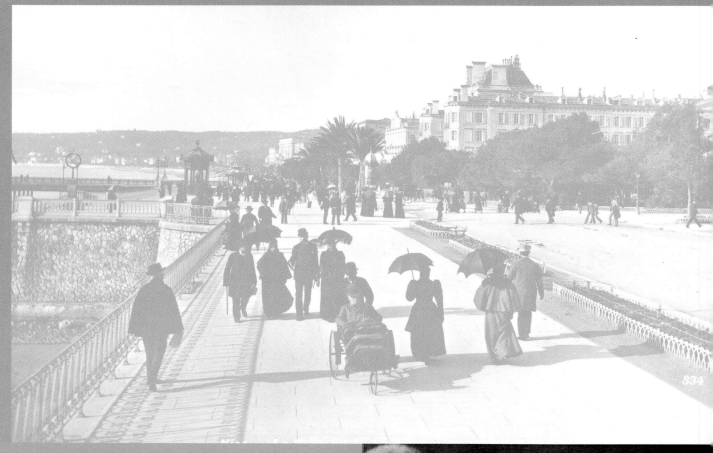

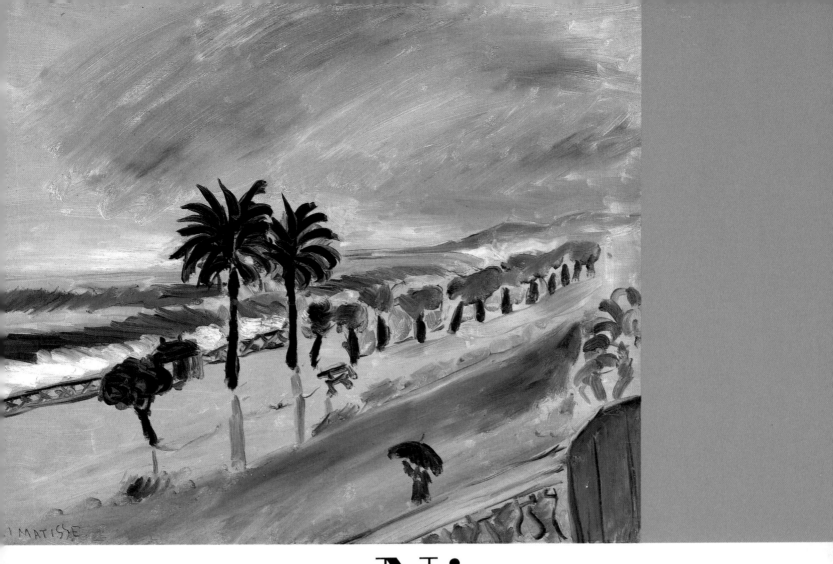

Nice

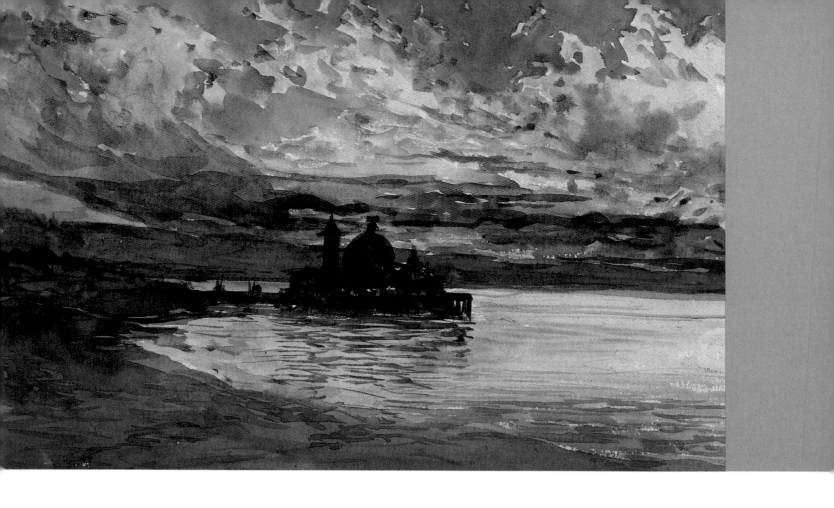

A city of rich and complex origins, Nice has a history all to itself. We should remember two things here: firstly, that Nice was Italian until 1860; and secondly, that the new lease of life given the city by the House of Savoy gave birth to a remarkable group of painters known as the Nice School, centered around Louis Brea and active from the early fifteenth century to the mid-sixteenth century. The number of paintings from the period preserved in local churches bear testimony to the School's success. At the end of the nineteenth century, Nice once again assumed its role as an artistic crossroads, and welcomed most of contemporary painting's major names, all of whom recognized how much of their inspiration was due to the city's light.

Prior to the arrival of the great names of modern art, and rather than experimenting with color, the city's indigenous painters focused on accurate, topographical renditions of the local landscape. In his *Vue de Nice depuis le Lazaret* (page 148-9), François Bensa made an unusual choice in radically opposing the sea and sky with the coast, the former executed in a smooth, blended brushstroke, the latter meticulously painted with an almost Flemish attention to detail. While the result gives the impression of an art that seems to hesitate between the fluid, well-balanced atmo-

sphere of Alexis Mossa, and the concern for detail of the Cannes School, the importance of the work as a record of how this landscape has changed since Bensa depicted it is undeniable.

Alexis and his son Gustav-Adolf Mossa are inseparable from the history of Nice. Although his family was originally from Nice, Alexis was born in Santa Fe de Bogotà, Colombia. After spending time at Cabanel's Paris studio, he decided to return to the land of his ancestors. It can be said that Alexis Mossa was the true innovator of a painting style specific to Nice. Not only did he resurrect the original Nice School, but he also founded the Société des Beaux-Arts, the city's future national school of decorative arts. In addition, he reinstated the Nice Carnival with its procession of decorated floats, before becoming the curator of the city's first fine arts museum. Alongside his luminous, precise landscapes inspired by Impressionism that give us a view of the Nice region before its touristic development, Alexis Mossa has also left us his designs for the carnival floats he promoted. Among his works, there are no less than eight thousand watercolor landscapes (each num-

Opposite:
Alexis Mossa,
Le Casino de la Jetée,
Promenade à Nice.
Watercolor. Musée d'art et d'histoire, Palais Masséna, Nice.
———
The Palais de la Jetée at the beginning of the twentieth century, since demolished.

bered, dating from 1863 to 1926) which evolve from rather dark renditions, executed just after his stay in Barbizon, to progressively more luminous ones, as seen in *Le Casino de la Jetée, Promenade à Nice* (page 146).

On the other hand, the work of his son Gustav-Adolf (1883–1971) lay far from this luminosity, and some of his symbolist paintings inspire a sense of anxiety in the viewer. In a fantastical setting steeped in sexual or morbid themes, he represents woman as both angel and devil. This period would last from 1903 to 1917, when Gustav-Adolf returned to landscapes and the Carnival, the taste for which he inherited from his father.

Once Matisse discovered the Mediterranean in 1898, he

François Bensa,
Vue de Nice depuis le Lazaret.
Oil on canvas. Musée d'art
et d'histoire, Palais Masséna, Nice.

was never away for long. It was in 1917 that he first came
to Nice. Fascinated by the purity of its light, he finally set-
tled here in 1921. Until 1938, he lived at 1, place Charles
Félix, in an eighteenth-century building from whose win-
dows he could see not only all of Nice, but also Cannes
and Cap d'Antibes. From his first stay in Nice until his
death, Matisse would, without exception, spend October
through May in the city. His time with Renoir in
Cagnes—along with the general post-war atmosphere of
life getting back to normal—helped bring more sensuality
to his work. In particular, he painted a series of light-filled
interiors inhabited by a semi-clothed odalisque, whose role
in the composition is both decorative and emotional, as in

Odalisque au coffret rouge (page 151). Although he was mainly preoccupied with interior scenes, Matisse sometimes ventured out of doors to create landscapes such as *Tempête à Nice* (page 145). Once he had overcome the influences of his youth, the artist revealed his characteristic taste for stylized forms, as well as an extreme concern for balancing colors. Through the beauty of the southern light and the calmness of flat planes of color, Matisse conveys his happy, restful view of life. Here, he painted the Baie des Anges and his "windows," inventing a new relationship between himself and nature. When asked in a 1942 radio interview about the charm of his paintings with open windows, he answered, "It probably comes from the fact that, as I feel it, space is all one from the horizon to the interior of my studio bedroom, and the passing boat exists in the same space as the familiar objects around me; the window wall doesn't create two different worlds."[9] In 1938, Matisse moved to the Hôtel Regina in Cimiez. During the war, when he faced both personal illness and the imprisonment of his wife who worked with the Resistance, he turned more and more to making his famous gouache on paper cut-outs. Before his death in 1954, he made a donation of works which would constitute the core of the museum installed in the seventeenth-century Villa des Arènes on the Colline de Cimiez, between the Hôtel Regina where Matisse had lived and the cemetery where he now rests. Today, the Musée Matisse exhibits work from every period of the painter's career, from his first work, *Nature morte aux livres,* to one of his last gouaches, *Fleurs et fruits,* which is the painter's largest work remaining in France (13 feet across by nearly 30 feet high).

It was during this same period, in 1940, that Nicolas de Staël moved to Nice. Often in the company of Surrealist and Abstract artists, he began to question the foundation of his figurative approach. Countless other artistic memories are preserved in Nice. Located in the middle of a park filled with olive trees, the Musée Marc Chagall was specially built in 1970 so that Chagall's seventeen large-scale paintings depicting biblical subjects could be displayed in optimal conditions. As for Raoul Dufy, a rich collection of his landscapes is housed in the former arsenal building on the bay.

It would, however, be a mistake to conclude that with all the museums, as rich as they are pleasant, contemporary painting has been abandoned. The love story between Nice and the world of painting did not fade away with the death of Matisse. In the 1950s and 1960s, Nice experienced the same extraordinary artistic renewal that it had known

Henri Matisse,
Odalisque au coffret Rouge.
1926. Oil on canvas.
Musée Matisse, Nice.

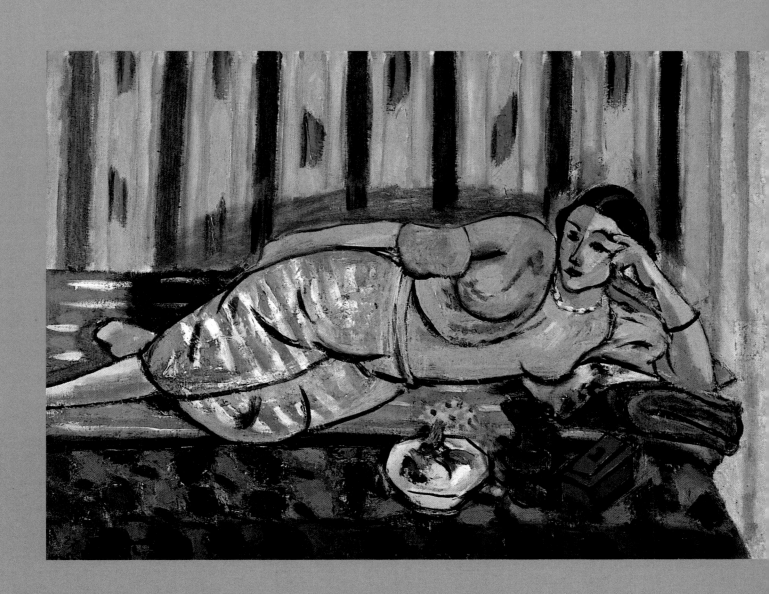

François Bensa,
Vue de Nice.
Oil on canvas.
Musée d'art et d'histoire,
Palais Masséna, Nice.

earlier in the century, with artists such as Robert Malaval, Claude Gilli, Ben and Jean-Claude Farhi spending time here. In fact, in the early 1960s, the success of a group of young local artists—which included Arman, Yves Klein and Martial Raysse—united under the label of the second Nice School. Lacking a unifying style, the modern Nice School quickly settled on a community of ideas which referred directly back to Dadaism, while at the same time prefiguring conceptual art. Its members considered an artist's attitude and the provocation of events more important than the actual creation of a work. Their philosophy was to show everyday beauty through consumer objects. In doing so, they developed Duchamp's lesson, albeit rather belatedly. In the 1960s, the Marseilles-born sculptor César, along with a

number of other artists, moved to Nice and transformed the city and its region into one of the key centers of contemporary art. The collection of the city's museum of modern and contemporary art shows the important role that Nice has played in innovative movements, as well as its close ties with the United States. The Nouveaux Réalistes—of whom Arman, Klein and Raysse form the Nice circle—are very well represented.

If Provence is the uncontested realm of painters, at the dawn of the third millenium its reign seems far from threatened. With its muted light inland and blazing sunshine along the coast, sandy shorelines and mountainous countrysides, bustling cities and remote villages, Provence continues to challenge artists who find inspiration in its eclectic harmony.

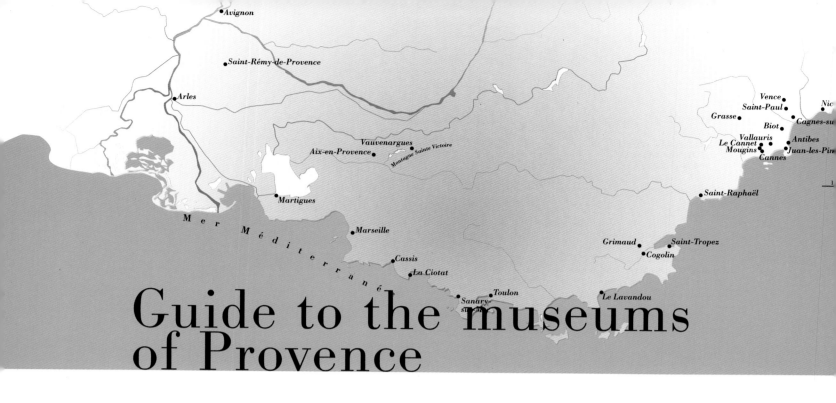

Avignon •
Saint-Rémy-de-Provence •
Arles •
Vauvenargues •
Aix-en-Provence •
Montagne Sainte Victoire
Martigues •
Mer Méditerranée
Marseille •
Cassis •
La Ciotat •
Sanary-sur-Mer
Toulon •
Le Lavandou •
Grimaud •
Cogolin •
Saint-Tropez •
Saint-Raphaël •
Vence •
Saint-Paul •
Nic...
Grasse •
Biot •
Cagnes-su...
Le Cannet •
Vallauris •
Antibes •
Mougins •
Cannes •
Juan-les-Pin...

Guide to the museums of Provence

Aix-en-Provence

Musée Granet
13, rue Cardinale, 13100 Aix-en-Provence.
Tel.: 04 42 38 14 70. Open daily from 10 a.m.
to 12 p.m. and from 2 p.m. to 6 p.m.
The museum, in an old priory of the Knights of Malta, owns and exhibits a rich collection of paintings including works by Cézanne, Ingres, Rubens and Rembrandt.

Atelier de Cézanne
9, avenue Paul-Cézanne, 13090 Aix-en-Provence.
Tel.: 04 42 21 06 53. Open daily, October through March, from
10 a.m. to 12 p.m and from 2 p.m. to 5 p.m.;
April through September from 10 a.m. to 12 p.m.
and from 2:30 p.m. to 6 p.m. Closed on holidays.
The studio of the painter is open to the public, with the objects that he used as models for his still lifes on display.

Antibes/Juan-les-Pins

Musée Picasso
Place Mariéjol, 06600 Antibes. Tel.: 04 92 90 54 20.
Open daily, June through September, from 10 a.m. to
6 p.m.; October through May, from 10 a.m. to 12 p.m.
and from 2 p.m. to 6 p.m. Closed Mondays and holidays.
The medieval Grimaldi chateau houses a collection of Pablo Picasso's works comprising paintings, drawings, engravings and ceramics that the artist created during his stay here. Also on display is Picasso's triptych *Satyr, faune et centaure*. The museum also has a collection of works by Nicolas de Staël.

Musée Magnelli/Musée Picasso
Place de la Libération, 06220 Vallauris.
Tel.: 04 93 64 16 05. Open daily, October through May, from
10 a.m. to 12 p.m. and from 2 p.m. to 6 p.m.;
June through September, from 10 a.m. to 6:30 p.m.
Closed Tuesdays and holidays.
Alberto Magnelli bequeathed a great number of canvases, engravings and collages to this museum located in an ancient priory. The museum also exhibits a collection of ceramics. The Musée Picasso is located in the chapel and houses a large mural entitled *La Guerre et la Paix*.

Arles

Musée Jacques Réattu
10, rue du Grand-Prieuré, 13200 Arles.
Tel.: 04 90 96 37 68. Open daily, October through March, from
10 a.m. to 12 p.m. and from 2 p.m. to 5 p.m.; April through
September from 9 a.m. to 12:30 p.m. and from 2 p.m. to 7 p.m.
The museum specializes in contemporary art, and is best known for a collection of fifty drawings donated by the Picasso foundation, as well as works from the Provençal school of the eighteenth and nineteenth centuries.

Avignon

Musée Calvet
65, rue Joseph-Vernet, 84000 Avignon.
Tel.: 04 90 86 33 84. Open daily from 10 a.m. to 1 p.m. and
from 2 p.m. to 6 p.m. Closed on Tuesdays and holidays.
Housed in a superb eighteenth-century mansion, the museum has an extensive collection of Provençal paintings and exhibits the works of artists such as Mignard and Claude-Joseph Vernet who, through the centuries, came to paint the local countryside.

Biot

Musée National Fernand Léger
Chemin du Val-de-Pôme, 06410 Biot.
Tel.: 04 92 91 50 30. Open daily, except Tuesdays,
from 10 a.m. to 12:30 p.m. and from 2 p.m. to 6 p.m.
This museums displays more than 300 pieces by Fernand Léger, including ceramics, mosaics, stained glass, tapestries and paintings.

Cagnes-sur-Mer

Musée Renoir
Chemin des Collettes, 06800 Cagnes-sur-Mer.
Tel.: 04 93 20 61 07. Open daily, October to May,
from 10 a.m. to 12 p.m. and from 2 p.m. to 5 p.m.;
June through September, from 10 a.m. to 12 p.m.
and from 2 p.m. to 6 p.m.
Auguste Renoir's home has not changed since his death. The museum visit entails a walk through the house where such renowned works as *Paysage des Collettes* and *Les Grandes Baigneuses* are on display. The artist's wooden chair and the outfits worn by his models are also exhibited.

Cannes

Musée de la Castre
Le Suquet, 06400 Cannes. Tel.: 04 93 38 55 26. Open daily,
October through June, from 10 a.m. to 12 p.m. and from
2 p.m. to 6 p.m.; July through September from 10 a.m.
to 12 p.m. and from 3 p.m. to 7 p.m. Closed Tuesdays.
In an old chateau once belonging to Lérins priests, this museum's specialty is ethnology and Mediterranean archeology. It also has a large section dedicated to Pellegrino, Crémieux, Buttura and Contini, among others.

Grasse

Musée Fragonard
23, boulevard Fragonard, 06130 Grasse.
Tel.: 04 93 36 02 71. Open daily, October through May, from
10 a.m. to 12:30 p.m. and from 2 p.m. to 5:30 p.m.; June
through September, from 10 a.m. to 7 p.m.
Closed Tuesdays and holidays.
The best reason to visit this museum in the beautiful villa of Fragonard's cousin is to see the original trompe l'œil mural painted by Fragonard on the staircase. All other paintings on display are copies.

Marseilles

Musée Cantini
19, rue Grignan, 13006 Marseilles. Tel.: 04 91 54 77 75. Open daily, October through May, from 10 a.m. to 5 p.m.; June through September from 11 a.m. to 6 p.m.
Closed Mondays.
Located in a private mansion, the museum contains works of some ot the greatest masters of modern art: Picasso, Bacon, Dufy, Le Corbusier, Léger, Picabia, Miró.

Musée des Beaux-Arts
Palais Longchamp
13004 Marseilles. Tel.: 04 91 14 59 30. Open daily, October through May, from 10 a.m. to 5 p.m.; June through September from 11 a.m. to 6 p.m.
Closed on Mondays and holidays.
Located in one of the wings of the Longchamp palace, this museum is an homage to the Provençal school of the seventeenth and eighteenth centuries and exhibits paintings by Mignard, Puget, Monticelli, Loubon and Guigou. The French, Italian and Flemish schools are also represented by such artists as Perugina, Rubens, Vouet, David and Courbet.

Martigues

Musée Ziem
Boulevard du 14-Juillet, 13500 Martigues.
Tel.: 04 42 80 66 06. Open Wednesday through Sunday, September to June from 2:30 p.m. to 6:30 p.m.
Open daily, except Tuesdays, July and August from 10 a.m. to 12 p.m. and from 2:30 p.m. to 6:30 p.m.
The museum was founded with a donation by Félix Ziem at the beginning of the twentieth century. In addition to hundreds of canvases and thousands of drawings, the museum also presents reproductions of different artists' studios.

Menton

Musée des Beaux-Arts
Palais Carnolès
3, avenue de la Madone, 06500 Menton.
Tel.: 04 93 35 49 71. Open daily from 10 a.m. to 12 p.m. and from 2 p.m. to 6 p.m. Closed Tuesdays and holidays.
This old summer residence for the princes of Monaco has become a museum that exhibits works from the thirteenth through the twentieth centuries. In addition to a collection of such modern artists as Dufy and Kisling, there is also a permanent exhibit of Italian primitive art.

Nice

Musée des Beaux-Arts Jules Chéret
33, avenue des Baumettes, 06000 Nice.
Tel.: 04 92 15 28 28. Open daily from 10 a.m. to 12 p.m. and from 2 p.m. to 6 p.m. Closed Mondays and holidays.
This former private mansion has become a museum of fine arts, exhibiting works by van Loo and van Dongen, as well as Impressionist paintings and works by Fragonard. Two rooms are dedicated to the works of Raoul Dufy, Alexis Mossa and his son, Gustav-Adolf Mossa.

Musée Matisse
164, avenue des Arènes de Cimiez, 06000 Nice.
Tel.: 04 93 81 08 08. Open daily, October through March, from 10 a.m. to 5 p.m.; April through September, from 10 a.m. to 6 p.m. Closed Tuesdays and holidays.
Matisse, having lived for almost forty years in Nice, bequeathed a large number of his artworks to the city. The museum, located in the beautiful villa of the Arènes, houses a stunning colleciton of drawings, engravings, paintings and illustrations.

Musée National Marc-Chagall
16, avenue du Docteur-Ménard, 06000 Nice.
Tel.: 04 93 53 87 20. Open daily, October through June, from 10 a.m. to 5 p.m.; July through September, from 10 a.m. to 6 p.m. Closed Tuesdays and holidays.
Built in the 1970s to house the seventeen large paintings of Chagall's *Message biblique*, this museum owns the largest collection of the artist's biblical works.

Musée d'Art et d'Histoire
Palais Masséna
65, rue de France, 06000 Nice. Tel.: 04 93 88 11 34.
Open daily, except Mondays, from 10 a.m. to 12 p.m. and from 2 p.m. to 6 p.m. The museum is undergoing renovations and is scheduled to reopen in the fall of 2001.
Installed in a grand palace, this museum has a lovely collection of religious art, ceramics and jewelry. The Chevalier de Cesolle library housed within the museum has an important collection of regional works, as well as some paintings by Alexis Mossa.

Saint-Paul

Fondation Maeght
623, Chemin des Gardettes, 06570 Saint-Paul.
Tel.: 04 93 32 81 63. Open daily, July through September, from 10 a.m. to 7 p.m.; October through June, from 10 a.m. to 12:30 p.m. and from 2:30 p.m. to 6 p.m.
This famous collection includes all the great names in modern art: Giacometti, Calder, Miró, Zadkine, Braque, Chagall. Many of the artists exhibited worked alongside the Catalan architect Josep-Luis Sert, and their monumental works of art are intrinsic to the building and the surrounding park.

Saint-Rémy

Centre d'art présence van Gogh
Hôtel Estrine
8, rue Estrine, 13210 Saint-Rémy-de-Provence.
Tel.: 04 90 92 34 72. Open daily, from 10:30 a.m. to 12:30 p.m. and from 2:30 a.m. to 6:30 p.m.
Closed Mondays, the months of January through March and for 3 weeks in November.
This mansion dates from the eighteenth century. It has recently become home to the Centre d'art présence van Gogh, and presents documentary screenings and theme-based exhibits on van Gogh's life and work. The museum also shows temporary exhibits of contemporary art.

Saint-Tropez

Musée de l'Annonciade
Place Grammont, 83990 Saint-Tropez.
Tel.: 04 94 97 04 01. Open daily, October through May, from 10 a.m. to 12 p.m. and from 2 p.m. to 6 p.m.; June through September, from 10 a.m. to 12 p.m. and from 3 p.m. to 7 p.m. Closed Tuesdays and holidays.
The museum, housed in this old chapel since 1955, exhibits a group of fifty works of art collected by the industrialist Georges Grammont. This fine collection includes sculptures and paintings by Derain, Dunoyer de Segonzac, Signac, Seurat, Bonnard, Matisse, Van Dongen, Roussel and Denis.

Toulon

Musée des Beaux-Arts
113, boulevard du Maréchal-Leclerc, 83000 Toulon.
Tel.: 04 94 36 81 00. Open daily from 1 p.m. to 6 p.m., and during June and July, from 1 p.m. to 7 p.m.
Closed on holidays.
The museum honors local artists and those who adopted the region as their own, immortalizing the charms of the landscapes around Toulon. Its collection includes paintings by Vernet, Courdouan, Olive, Monticelli, Loubon, Dauphin, Nattero, etc.

Vence

La Chapelle du Rosaire
466, avenue Henri-Matisse, 06150 Vence.
Tel.: 04 93 58 03 26. Open Monday, Wednesday, Friday and Saturday from 2 p.m. to 5 p.m., Tuesday and Thursday from 10 a.m. to 11:30 a.m. and from 2 p.m. to 5 p.m. Closed on holidays.
The decoration of this chapel executed by Matisse from 1949 to 1951 is considered to be one of the artist's great masterpieces. The white ceramic walls are covered with large-scale black line drawings and reflect the lively colors of the stained glass windows. Matisse designed every detail in the chapel, including the altar and the priests' vestments.

Artists' biographies

Louis-Auguste Aiguier
(Toulon, 1819 – Le Pradet, 1865)
Louis-Auguste Aiguier taught himself to paint before he began to take classes at the Aubert drawing school in Marseilles. A farmer's son, he spent most of his life near Marseilles. He had a natural gift for seascapes, which he painted in the manner of Vernet, and in which the calanques de Cassis are a recurring theme. Encouraged by Loubon, he first exhibited his work in Marseilles in 1846, later participating in the Paris Salon and exhibiting in London. He worked slowly and left only around forty paintings to his name.

Albert André
(Lyon, 1869 – Avignon, 1954)
A disciple of Renoir, André worked in an impressionist style painting figured landscapes. In 1918, he became the curator of the Musée Bagnols-sur-Cèze, where he brought together the works of such friends as Matisse, Bonnard and Valtat.

François Bensa
(Nice, 1811 – Nice, 1895)
Bensa first studied under Paul Émile Barbéri, the influential director of Nice's school of drawing and architecture from 1823. He subsequently left for Rome to work in Joseph Castel's studio, where he was initiated into the tradition of landscape painting. In 1834, he returned to Nice where he gave more and more importance to light in his paintings, evolving from historical to naturalist landscapes. His freedom of expression lends his paintings a great sense of freshness.

Pierre Bonnard
(Fontenay-aux-Roses, 1867 – Le Cannet, 1947)
Bonnard founded the Nabis group along with Sérusier, Ranson, Roussel and Vuillard. From his early impressionistic paintings inspired by Corot and Pissarro, mostly depicting street scenes and Paris life, he moved to more neutral colors and sinuous lines associated with the Nabi aesthetic. From around 1910, Bonnard made frequent trips to Vernon in the Seine River valley and then to Le Cannet where he bought his villa, Le Bosquet, in 1926. Until the end of his life, he concentrated on color and light in his landscapes, nudes and still lifes.

Eugène Boudin
(Honfleur, 1824 – Deauville, 1898)
Boudin is considered a precursor to the Impressionists, both in his attitude toward nature and in his technique. He was Monet's teacher, giving the young artist his first open-air lessons in 1858. His favorite subject was the Normandy coast. He used pearly gray tones in his scenes of the sea, the beach and the changing skies. The discovery of the light of the Midi was a revelation, yet even when painting in the south, he continued to use his same palette of colors in evocative landscapes of the region.

Georges Braque
(Argenteuil, 1882 – Paris, 1963)
After a Fauvist period influenced by Matisse and Derain, Braque was profoundly marked by Cézanne's paintings as well as by his first meeting with Picasso, a prelude to their communal invention of Cubism. His canvases are characterized by their simple forms, geometric elements and austere colors. After first including stenciled letters and numbers in his compositions, Braque began to add other elements to his canvases: sand, sawdust, newspaper, packing paper. By the 1930s, he was working in a style freer than that of synthetic Cubism, concentrating on still lifes, of which the culmination was his great *Ateliers* series (1948–55).

Clément Brun
(Avignon, 1865 – Avignon, 1920)
Clément Brun, a watchmaker's son, showed a true gift for art, and won a great many prizes during his studies under Pierre Grivolas' cane at the Avignon École des Beaux-Arts. He was the recipient of several local scholarships which enabled him to further his education and thus hone his talent. Every year until 1914, he participated in the Paris Salon and exhibitions in Avignon. In 1899, he became the vice-director of the Académie Julian. After this prestigious step in his career, he was commissioned to paint many portraits and interiors throughout France. In 1901, he was put in charge of the decoration of the Lyon-Perrache train station.

Ernest Buttura
(Paris, 1841 – 1902?)
The son of a doctor to the royal family and deputy mayor of Cannes, Buttura entered the École des Beaux-Arts in Paris in 1861 and began to commute between Paris and Cannes, where he owned a studio. From 1863, he regularly exhibited his paintings at the Paris Salons, and became widely known in Paris and abroad. Inspired by the Var mountains, a recurring theme in his pictures, Buttura was also the author of medical articles about the healing properties of seawater and the climate of Cannes.

Charles Camoin
(Marseilles, 1879 – Paris, 1965)
Charles Camoin studied in Gustave Moreau's studio, where he met Manguin, Marquet and Matisse. He participated regularly in the Salon des Indépendants from 1903, and exhibited at the "Fauve" Salon d'Automne in 1905. Also influenced by Cézanne, whom he met in 1901, he ultimately remained closer to Impressionism than any other movement. In addition to nudes, he painted interior scenes, still lifes and landscapes characterized by their soft harmonies.

Carlos-Reymond
(Paris, 1884 – Paris, 1970)
Carlos-Reymond was a follower of Signac, adopting Neo-Impressionism—a Divisionist style in particular—

when he moved to Saint-Tropez at the beginning of the twentieth century. His travels in Brittany, along the Mediterranean coast and in Italy gave him the opportunity to paint seascapes flooded with light.

Marko Celebonovitch, aka Marko
(Belgrade, 1902 – Belgrade, 1986)
First a law and economics student, Marko spent several months in Bourdelle's studio before devoting himself exclusively to art. A figurative painter, Marko preferred still lifes, interior scenes and portraits. He was a professor at the School of Fine Arts in Belgrade for a while, but spent most of his life in France, living between Paris and the Midi.

Paul Cézanne
(Aix-en-Provence, 1839 – Aix-en-Provence, 1906)
Cézanne's first paintings demonstrate his admiration for Delacroix, Tintoretto, Rubens, Manet and Courbet. His art is characterized by a kind of expressionism in which romantic and realist influences intermingle. At Pissaro's urging, Cézanne moved closer to Impressionism but at the same time kept a safe distance. He then graduated to a more classical style, as his still lifes and landscapes of the Sainte-Victoire mountain show. At the end of his life, he rediscovered the romantic impulses that marked the beginning of his career, and his paintings became more agitated and vehement.

Marc Chagall
(Vitebsk, 1887 – Saint-Paul-de-Vence, 1985)
After finishing his studies in his hometown and Saint Petersburg, Chagall moved to Paris, where he became a member of the avant-garde group of artists living in Montparnasse. His paintings have never lost their enormous appeal: vivid and colorful, they draw on the memories of the artist's childhood, incorporating the folklore of his native country, popular Jewish legends and the Old Testament. Marc Chagall was also very interested in ceramics, bas relief and stained glass. From 1950 he made his home in Vence, where the abandoned Chapelle de Calvaire inspired his great *Message biblique* series.

Jean-Antoine Constantin
(Bonneveine, 1756 – Aix-en-Provence, 1844)
After an education with Kapeller the elder and David in Marseilles, Jean-Antoine Constantin left to study in Italy. When he returned to France, he became the director of the drawing school in Aix, and then a professor in Digne. This great master of watercolors was also an engraver and an oil painter, most notably of landscapes. He had a profound influence on the Provençal school.

Joseph Contini
(Milan, 1827 – Cannes, 1892)
Joseph Contini, the son of a Milanese merchant, moved to Cannes where he was married in 1863. A landscape artist and a pupil of Pasini, Contini gave drawing lessons, and painted frescos and numerous oil and watercolor

paintings. He participated in many shows in Cannes and exhibited his work on the Champ-de-Mars in Paris in 1878. He was awarded the order of the Crown of Italy by King Humbert.

Vincent Courdouan
(Toulon, 1810 – Toulon, 1893)
From 1822, Courdouan took drawing lessons from Pierre Létuaire and then entered the École des Beaux-Arts de la Marine, which was directed at the time by the sculptor Clément Brun. In 1829, Courdouan moved to Paris to learn the art of engraving and spent a great deal of time in the studio of the Toulon painter, Paulin Guérin. After moving back to Toulon permanently in 1830, he began to produce numerous graphite sketches, tints, washes and watercolors. In 1838, he became a professor at the naval college in Toulon. Courdouan's paintings, in particular his seascapes and forest scenes, are often rather austere, though his focus on light, often captured in works from his voyages to exotic destinations, including Egypt and Algeria, provided inspiration for later Orientalists.

Édouard Crémieux
(Marseilles, 1856 – deported in 1944)
A student of Bouguereau, Crémieux exhibited at the Salon des Artistes Français, where he became a member in 1884. He received an honorable mention in 1892 and the third-place medal in 1895. His views of Cassis and of the bay of Marseilles are among his most famous paintings.

Henri-Edmond Cross
(Douai, 1856 – Le Lavandou, 1910)
Although initially influenced by Impressionism, by 1891 Cross was painting using the Divisionist technique. Friends with many painters, he founded, along with Seurat and Signac, the Salon des Indépendants. After 1900, he left for the Midi with Signac and Matisse and once there, distanced himself from the rigors of Divisionism, painting landscapes, seascapes and portraits.

Eugène Dauphin
(Toulon, 1857 – Paris, 1930)
Dauphin studied under Vincent Courdouan, whose influence can clearly be discerned in his works. He painted landscapes and seascapes around his native Toulon and exhibited at the Salon from 1880.

Pierre Decoréis
(Ollioules, 1834 – La Garde, 1902)
The godson of Pierre Létuaire, Decoréis taught drawing in various schools and presented his work at the Salon des Artistes Français and at the Toulon Salon. Decoréis' topographical paintings of the region stand as reminders of how terribly it has suffered under recent urbanism.

André Derain
(Chatou, 1880 – Garches, 1954)
Derain studied in Paris where he met Matisse, then, having completed his military service, spent the summer of 1905 in Collioure. This was the catalyst for his Fauve period. In the Midi, Derain worked alongside Vlaminck, Matisse, Dufy and Braque. His later works are more somber and show different influences, including that of African and Oceanic art.

Raoul Dufy
(Le Havre, 1877 – Forcalquier, 1953)
Greatly influenced by Matisse and Marquet, in 1905 Dufy was converted from Impressionism to the new brightly colored style of the Fauves. During a stay in the south of France with Braque in 1908, he began to produce works of art that were more structured and in a darker palette than his earlier paintings. Evolving toward a simplification of form and color, Dufy's preferred subjects were landscapes, cityscapes and nautical scenes. He was also interested in engravings and ceramics, worked for a fine silk manufacturer, and drew fabric designs for the fashion designer Paul Poiret.

André Dunoyer de Segonzac
(Boussy-Saint-Antoine, 1884 – Paris, 1974)
A friend of La Fresnaye and Boussingault, with whom he shared a studio, Dunoyer de Segonzac began his career by painting still lifes. In 1908 he discovered Saint-Tropez where he painted his first landscapes. His works of art are characterized either by their muted sense of color, as seen in his landscapes of the Ile de France, or, in contrast, by the

harmonies and colors influenced by the light of the Midi. He dedicated a large part of his life to drawings, watercolors, etched engravings and book illustrations.

Achille Empéraire
(Aix-en-Provence, 1829 – Aix-en-Provence, 1898)
Empéraire took courses at the drawing school in Aix from 1844 to 1856, and then left for Paris, where he studied at the Académie Suisse at the same time as Cézanne. He worked in Thomas Couture's studio but was soon disillusioned. This is captured in Cézanne's magnificent portrait of him (1868–70). Taking refuge in his hometown, Empéraire, an ardent Republican, often sat in the café Beaufort to discuss politics and art with a group of modernists from Aix. However, he spent most of his time working in a cottage on the road to Thoronet.

Jean-Honoré Fragonard
(Grasse, 1732 – Paris, 1806)
A student of Chardin and Boucher, Fragonard is one of the key figures of French eighteenth-century painting. After his studies, he traveled in Italy sketching the monuments, antiquities and landscapes that he came across. He also produced numerous sketches in red chalk and bistre washes. In France, he completed frescos and decorative paintings, most notably for Madame de Pompadour.

Othon Friesz
(Le Havre, 1879 – Paris, 1949)
Initially influenced by the Impressionists, Friesz rallied to Matisse's side and became part of the Fauve movement. Under Cézanne's influence in 1908, he decided to leave the group. He went on several journeys, discovered the south of France, and moved to Toulon. His varied works of art include landscapes, nudes, still lifes and portraits, all characterized by their subdued use of color.

Joseph Garibaldi
(Marseilles, 1863 – Marseilles, 1941)
Garibaldi was a student of Antoine Vollon, who owned a studio in the old port of Marseilles. From 1883, Garibaldi exhibited his Provençal landscapes at the Paris Salon, where he was given an honorable mention in 1887, and a third-class medal in 1897. Garibaldi worked mostly in Marseilles and its surroundings. In 1916, he exhibited his landscapes at the Exposition Coloniale in Marseilles and at the Marseilles Salon, where he became a member of the jury and vice-president of the administrative commission. His works are well represented in museums throughout Provence as well as in many other French public collections.

Paul Gauguin
(Paris, 1848 – Marquesas Islands, 1903)
Along with his friend Pissarro, Gauguin participated in the first Impressionist exhibitions. In 1886, he broke away from Impressionism and moved to Pont-Aven in Brittany where, alongside Émile Bernard, he elaborated the details of Synthetism, which, instead of muted harmonies, favored the use of wide areas of pure, bold color. A short visit to see van Gogh in Arles in 1888 was unsuccessful (the artists quarreled and Gauguin's departure was followed by van Gogh's first breakdown), but had a strong effect on Gauguin's perception of light.

François-Marius Granet
(Aix-en-Provence, 1775 – Aix-en-Provence, 1849)
Granet was a pupil in Jean-Louis David's Paris studio, before leaving for Rome where he lived for almost eighteen years. He became well-known for his dimly lit interior scenes, which gave him a solid reputation and influenced many Provençal artists, including Cézanne. In addition to his Italian landscapes, the painter specialized in depicting church interiors, cloisters and ruins. In 1848, to escape the Revolution, he moved to Aix-en-Provence where he painted numerous watercolor landscapes and genre scenes. It was in Aix that he later founded the museum that bears his name.

Prosper Grésy
(Boulogne-sur-Mer, 1804 – Nice, 1874)
Considered by his contemporaries to be a pioneer of the Provençal school, Grésy was, to begin with, a minor government official in the north of France. A posting in Arles came as a revelation to him: already an amateur artist, the strong light compelled him to paint. Concurrent with his professional career, which also took him

to Aix-en-Provence and then Marseilles, he was gripped by a passion for the Provençal countryside. Painting was so important to him that at the end of his life, when he could no longer hold a paintbrush in his right hand, he learned to paint with his thumb. Grésy helped young painters like Guigou to achieve recognition.

Pierre Grivolas
(Avignon, 1863 – Avignon, 1906)
Director of the Avignon École des Beaux-Arts, Grivolas influenced many Provençal painters, most notably his students Seyssaud and Chabaud. His paintings are exhibited at the Musée d'Avignon.

Moïse Kisling
(Cracow, 1891 – Sanary, 1953)
Upon his arrival in France, Polish-born Kisling befriended Max Jacob, Picasso, Chagall and Soutine. After World War I, he became one of the leading personalities of the École de Paris. His works—still lifes, nudes and female portraits—are characterized by their deliberate and precise drawing, use of transparency and brilliant palette.

Henri Lebasque
(Champigné, 1865 – Le Cannet, 1937)
Lebasque worked in the Seine River valley, in Auvergne and in Provence. Linked to the Pissarro family, Paul Signac and Maximilien Luce, he was largely influenced by the Impressionists, but from 1905 a distinct leaning toward Fauvism can be discerned in his work.

Fernand Léger
(Argentan, 1881 – Gif-sur-Yvette, 1955)
Léger's first paintings are marked in turn by Impressionism and Fauvism. Strongly influenced by Cézanne, he began to work with shapes and colors, geometrically dividing space and giving color a dominant role. The war inspired Léger to represent, in a geometric style, mechanical forms (motors, propellers) and human figures that resembled robots. His works of art are characterized by their architectural composition and rigor of form and color. These elements can also be found in his film and theater sets, as well as in his stained glass. The Léger museum in Biot exhibits a broad selection of the artist's work.

Léo Lelée
(Chemazé, 1872 – Arles, 1947)
After a career as an ornamenter in the north of France and in Paris, this native of Angers came to Arles almost by accident. The countryside so fascinated him that he settled there permanently, becoming close with Baroncelli and Mistral, and marrying a woman from La Roquette. His works chronicle the festivities of the Félibrige group and of the Camargue area. In his studio across from Arles' ampitheater, he painted a large number of works which he bequeathed by the hundreds to Arles' Museon Arlaten, founded by Mistral in 1896.

Alfred Lombard
(Marseilles, 1884 – Toulon, 1973)
Son of a bourgeois family, Lombard studied literature and history at the University of Aix-en-Provence before deciding to dedicate himself to painting. In 1903 he enrolled at the Marseilles École des Beaux-Arts. The stiff and academic teaching style was not, however, what he had been looking for, and he only stayed a few months. After 1905, he began exhibiting at the Salon d'Automne, and in 1914, the Rosenberg gallery held the first of only two personal exhibits of his work.

André Lhote
(Bordeaux, 1885 – Paris, 1962)
Apprentice to a wood-carver in Bordeaux in as early as 1892, Lhote, a man of great culture, was searching for a modern language that would reconcile tradition with the lessons of Cézanne and Gauguin (whose work he discovered in 1906). He evolved in 1917 toward a synthetic Cubism before founding the Académie Montparnasse in 1922. Lhote published many essays on art, including a treaty on landscape (*Traité du paysage*, 1939).

Émile Loubon
(Aix-en-Provence, 1809 – Marseilles, 1863)
A former pupil of Granet, Émile Loubon became the director of the Marseilles École des Beaux-Arts, where he played a vital role for Provençal artists by introducing

them to the contemporary tendencies of the Parisian artistic community from 1846. This should not eclipse the quality of his paintings: the substance of his preparatory sketches, the spontaneity of his drawing, and the vivacity of his brushstroke. His compositions place him among the most respected Provençal painters of his time.

Maximilien Luce
(Paris, 1858 – Saint-Clair, 1941)
Luce was first a wood engraver before turning to painting. He associated with various different artists including Signac, Seurat and Pissarro, and his artworks evolved from Pointillism toward an impressionistic style lightly touched by Fauvism.

Alberto Magnelli
(Florence, 1888 – Meudon, 1971)
Associated first with the Futurist avant-garde in his hometown, then with the Cubist movement in Paris, Magnelli subsequently pursued a more personal route toward a radical simplification of shape and color. He then went back to a more figurative style which he developed during the 1930s before returning to an abstraction organized by overlapping and fragmented planes.

Joseph Mange
(Toulon, 1866 – Toulon, 1935)
A lover of the south of France, Mange never tired of painting the most beautiful aspects of the region: sunlit beaches, inlets and blossoming almond trees.

Henri Manguin
(Paris, 1874 – Saint-Tropez, 1949)
Manguin met the painters Marquet, Rouault and Matisse when a student of Gustave Moreau. He participated in the Salon d'Automne of 1905 where Fauvism made its first explosive appearance. His works were often executed in the Midi, notably in Saint-Tropez, which he discovered thanks to Paul Signac.

Albert Marquet
(Bordeaux, 1875 – Paris, 1947)
Along with Matisse, whom he met during his studies in Paris, Marquet painted in the Luxembourg Gardens and along the banks of the Seine. He traveled to Normandy to continue working there with Dufy, and then to the Midi, where he met Signac and Cross. From 1905, the artist painted highly colorful works and took part in the Fauvist exhibitions. He later graduated to a more moderate palette, using a wide range of grays. Beside his ports of the Midi, he also painted numerous landscapes, views of Paris and some portraits.

Henri Matisse
(Le Cateau-Cambrésis, 1869 – Nice, 1954)
Matisse's early works indicate an Impressionist influence. After a series of nudes and austere still lifes, Matisse became inspired by Cézanne and drew closer to Pointillism. Then, after a stay in Saint-Tropez in 1904, and in Collioure in 1905, he began to paint with glowing colors; it is at this point that he became the leading figure of the Fauves. His following works, influenced by his travels, his taste for Algerian ceramics and Russian icons, the discovery of the Midi and his meeting with Renoir, are characterized by their monumental arabesques, vibrant fields of color and a strong sense of volume.

Louis Montagné
(Avignon, 1879 – Paris, 1960)
With a future as an accountant mapped out for him, Montagné preferred to turn to art, studying with Paul Saïn and then Cormon in Paris, where he became a member of the jury for the Salon des Artistes Français. In 1920, he became director of the Avignon school of art, alternating his stays between Paris and his hometown. His paintings, however, were always faithful to the Provençal landscape and the evocation of country scenes.

Adolphe Monticelli
(Marseilles, 1824 – Marseilles, 1886)
The son of a family of Italian origin living in Marseilles, Monticelli received the drawing prize from the city's École des Beaux-Arts in 1843. He then studied in Paul Delaroche's studio, but it was in the Paris Louvre that he discovered his true masters. After many stays in the capital, in 1870 he returned permanently to Marseilles where he matured as a painter. An admirer of Delacroix, Monticelli

continued to produce imaginative mis-en-scènes, but retained a realist eye for portraits, still lifes, bouquets with astonishing colors and landscapes saturated with sunlight.

Alexis Mossa
(Santa Fe de Bogotà, 1844 – Nice, 1926)
Mossa, a student of Picot and Cabanel, founded the École des Arts décoratifs in Nice. He painted genre scenes, portraits and landscapes, notably watercolors of Nice and its surroundings.

Louis Nattero
(Marseilles, 1875 – Marseilles, 1915)
Nattero began his studies at the Marseilles École des Beaux-Arts before taking classes in Léon Bonnat's studio in Paris. After 1898, he moved to Marseilles where he gave painting classes in his studio, encouraging his students to paint naturalist landscapes at different times of the day. A landscape painter himself, he specialized in seascapes which he painted along the Marseilles coast around Martigues.

Jean-Baptiste Olive
(Marseilles, 1848 – Paris, 1936)
The son of a wine merchant, Olive began as an apprentice sign painter before studying at the École des Beaux-Arts in his native town. He exhibited at the Paris Salon from 1874, and was often rewarded by the jury. Though he lived in Paris, Olive is known for his numerous Provençal landscapes in addition to his views of Venice and of the countryside around the French capital.

Auguste Pégurier
(Saint-Tropez, 1856 – Paris, 1936)
A student at the Académie Julian, Pégurier also worked with Carolus-Duran. An amateur painter, he specialized in landscapes and maritime paintings, and is noted for his exhaustive views of Saint-Tropez, painted before Signac attracted closer attention to the village. Pégurier exhibited in various Salons (Artistes Français, Indépendants, etc.) where his talent was soon recognized—though he only gained broad recognition after his death.

Charles Pellegrin
(1837? – Marseilles, 1936)
Very little is known about this painter, whose name is associated with his views of Martigues, except for his close friendship with Monticelli.

Charles-Henri Person
(Amiens, 1876 – Paris, 1926)
A student of Cormon, Wallet, Humbert and Thirion, Person painted landscapes in light colors, initially favoring the Pointillist technique. A few of his later paintings can be seen as heralds of Tachism.

Jean Peské
(Bohemia, 1870 – Le Mans, 1949)
Peské was marked by the Impressionists without being a true disciple. He inherited their gift for simplification and used light colors in his paintings. Drawn by the Midi, he painted in Bormes and Saint-Tropez.

Francis Picabia
(Paris, 1878 – Paris, 1953)
First known for his Impressionist paintings, Picabia explored abstraction and Cubism before working through an eclectic range of styles. With Marcel Duchamp, he developed pre-Dadaist activities and became the propagator of the Dada movement. Picabia's artistic output is extremely diverse (essays, journals, paintings, collages, ballet formations).

Pablo Picasso
(Malaga, 1881 – Mougins, 1973)
One of the most important artists of the twentieth century, Picasso nourished his art with diverse influences. After an academic training, he was especially touched by the art of medieval Spain, El Greco, Toulouse-Lautrec and Munch. For a while, he put great importance into psychological content as can be seen in his works from "Blue Period," where he explored moral and physical misery, and from his "Rose Period," during which his visions appeared much more optimistic. A wide range of interests (Iberian sculpture, Cézanne's "black" paintings, Ingres, Gauguin), and his meetings with fellow artists (Matisse, Braque, Derain), helped Picasso forge the path to Cubism and abstraction. Working in the Midi

enriched the creative passion of this prolific genius, and here he dedicated much of his time to ceramics, lithography, sketches and sculpture.

Félix Pille
(Cannes, 1848 – Cannes, 1919)
Pille lived at 56, route de Fréjus, in his boutique *Cannes Artistique*, where he exhibited his work and sold his canvases to passing tourists. In addition, he painted storefronts and worked as a decorator.

Luc Raphaël Ponson
(Solliès-Pont, 1835 – Marseilles, 1904)
Ponson's father, a theater decorator, taught him the rudiments of painting and registered him at the Marseilles École des Beaux-Arts where, at Loubon's side, he learned landscape painting. A stay in Paris from 1855 to 1856 allowed him to study at the Louvre, while a job as a fan decorator provided him with the means to live in the capital. He subsequently moved to Marseilles, then traveled to Italy and finished his training. He had his debut exhibit at the Marseilles Salon in 1852 and in Paris in 1861. Ponson is best known for his paintings of the calanques near Marseilles.

Mario Prassinos
(Istanbul, 1916 – Eygalières, 1985)
At first close to Surrealism and Expressionism, Prassinos added a more personal edge to these styles, incorporating an interplay of colored and structured shapes into his paintings. From the 1960s, these same shapes became diluted by a kind of Pointillism, consisting in a thick web of strokes, dots and dabs, often in black and white.

Jean Puy
(Roanne, 1876 – Roanne, 1960)
A student at the École des Beaux-Arts in Lyon and then at the Académie Julian and the Académie Carrière in Paris, where he met Matisse, Puy was inspired by Impressionism before turning toward a discretely Fauvist style.

Joseph Ravaisou
(Bandol, 1865 – Aix-en-Provence, 1925)
Ravaisou was without a doubt the most ardent follower of Cézanne to come out of Aix. Almost all of his paintings are of Aix and its surroundings. Essentially a landscape artist, nature was for Ravaisou an eternal return. He moved to Aix as a young boy in 1878 and was immediately drawn to the arts. He took drawing classes from 1883 to 1884. At the age of seventeen, he became a school teacher, then was appointed director of the Mont-de-Piété school in 1912, which gave him financial security while allowing him to paint.

Jacques Réattu
(Arles, 1760 – Arles, 1833)
After sojourning in Italy, Réattu returned to France and in 1818 painted the ceiling of Marseilles' Grand Théâtre. Ten years later, he decorated the church of Beaucaire with three paintings representing the story of Saint Paul. His house in Arles has been converted into a museum exhibiting his art.

Pierre Auguste Renoir
(Limoges, 1841 – Cagnes-sur-Mer, 1919)
The initial works of Renoir, one of the foremost exponents of Impressionism, show the influence of artists as diverse as Fragonard, Veronese, Boucher, Delacroix, Courbet and Manet. Initially spending winters in the south, the painter settled in Cagnes from 1908.

Paul Saïn
(Avignon, 1853 – Avignon, 1908)
A student of Gilbert and Gérôme, Paul Saïn was praised by the Parisian critics beginning in 1880, recognition which opened the doors of the Louvre to him. He was unrivaled in the diversity and sheer quantity of his output: he painted at least 1600 portraits and large landscapes—principally of Provence and Corsica—for the Salons.

Georges Seurat
(Paris, 1859 – Paris, 1891)
Seurat is considered the founder of the Divisionist technique that is characterized by an optical mix and division of colors. Influenced by the work of Chevreul, Seurat undertook research on the colors that led him to juxtapose brushstrokes of pure colors on the canvas instead of mixing them on his palette.

Paul Signac
(Paris, 1863 – Paris, 1935)
Heavily influenced by Seurat, with whom he formed a close alliance in 1884, Signac adopted a Divisionist technique. He became the leader of the Neo-Impressionist group from 1891, and wrote the first history of the movement. He produced portraits and interior scenes, but was mostly known as a landscape artist, inspired by river banks and beaches. He painted the waters of Saint-Tropez, Brittany, Venice and La Rochelle.

Nicolas de Staël
(Saint Petersburg, 1914 – Antibes, 1955)
After studying in Brussels, Nicolas de Staël continued his education through his travels and museum visits where he discovered the work of the old masters, including Rembrandt and Vermeer. His paintings are characterized by their impasto and subtle colors. At the end of his life, in the Midi, he experimented with another form of painting altogether: his landscapes and still lifes from this period are marked by their fluidity and by a broad palette of warm and cool colors.

Alexandre Urbain
(Sainte-Marie-aux-Mines, 1875 – 1953?)
This painter and engraver exhibited in many Salons (Artistes Français, Indépendants). He is known for his prints and murals, especially those in the ballroom of the city hall of Vincennes.

Louis Valtat
(Dieppe, 1869 – Paris, 1952)
Valtat was initially influenced by the paintings of Toulouse-Lautrec, Monet and Gauguin, but from 1895 he drew closer to a style that can in retrospect be considered a precursor of Fauvism. He participated in the "Fauve" Salon d'Automne in 1905. Before moving permanently to the Paris region, Valtat spent fifteen years in Anthéor (near Saint-Raphaël) where he fell under the artistic influence of his neighbors Signac and Cross. During this period he completed magnificent landscapes of the Esterel.

Vincent van Gogh
(Groot-Zundert, 1853 – Auvers-sur-Oise, 1890)
The son of a pastor, van Gogh left his native Netherlands to discover Paris in 1886; from there he moved to Arles in 1888. When the artist first discovered the Midi, his palette was somewhat dark, but it soon lightened and diversified, and his colors became ever more vibrant. He was extraordinarily prolific when in the south, painting over two hundred canvases in his first fifteen months in Arles alone. A tormented man, van Gogh completed landscapes, still lifes, portraits and self-portraits which increasingly reflected his unease.

Mathieu Verdilhan
(Gard, 1875 – Marseilles, 1928)
Like many of his contemporaries, Verdilhan was first influenced by the Impressionist movement, only to develop later toward the bold use of color and energetic lines associated with the Fauves.

Claude-Joseph Vernet
(Avignon, 1714 – Paris, 1789)
As a student of Pannini in Rome and an inhabitant of Italy for many years, Vernet painted numerous views of Rome, Naples and its surroundings. He returned to Paris where he completed, in addition to the fifteen *Ports of France* commissioned by the marquis of Marigny, seascapes, storm scenes, shipwrecks—often by moonlight—all in discrete, gray tones.

Félix Ziem
(Beaune, 1821 – Paris, 1911)
Ziem, an Orientalist, painted a number of decorative and luminous landscapes and seascapes in Provence, but also in the Netherlands, Constantinople, Venice and Antwerp. The Musée Ziem in Martigues houses more than two thousand works by the artist.

Footnotes

1 *The Letters of Vincent van Gogh,*
 ed. Ronald de Leeuw, trans. Arnold Pomerans. London, 1996, p. 444.
2 Ibid., p. 454–5.
3 Translated from Charles Maurras, in *Provence Alpes Côte d'Azur*, Guides Bleus, Paris, p. 619.
4 Michael Hogg, *Cézanne, the First Modern Painter*. London, 1994, p. 23.

5 Ibid., p.81.
6 Translated from Françoise Baligand et al., *Henri-Edmond Cross*. Paris, 1998, p. 30.
7 Ibid.
8 In *Pierre Bonnard*. Exhibition catalog. London, 1966, p. 18.
9 Georges Duthuit, "Le tailleur de lumière," (Verve, 1958). Translation from Anette Robinson, *Matisse,* Paris, 1999, p. 69.

Quotations

page
17 Translated from *Gauguin, Lettres à sa femme et à ses amis*. Paris, 1998, p. 154.
27 Translated from an unidentified interview with Dufy on the subect of his painting. Typed manuscript, c. 1950. Bibliothèque d'Art et d'Archéologie, Paris.
43 Letter from Paul Cézanne to Camille Pissarro, L'Estaque, 2 July 1876.
69 Translated from André Derain, *Lettres à Vlaminck*. Paris, 1994, p. 161.

79 Translated from Françoise Baligand et al., *Henri-Edmond Cross 1856–1910*. Paris, 1999, p. 30.
108 Translated from Guy de Maupassant, "De Cannes à Aguy," in *Sur l'eau*. Paris, 1992.
117 In Julian Bell, *Bonnard*. London, 1994, p. 88.
127 In Colin B. Bailey, *Renoir's Portraits: Impressions of an Age*. New Haven and London, 1997, p. 248.

Selected bibliography

AUTHOR'S SELECTION
Alauzen, André. *Dictionnaire des peintres et sculpteurs de Provence, Alpes, Côte d'Azur*. Marseilles, 1986.
Alauzen, André. *La peinture en Provence du XIXe siècle à nos jours*. Marseilles, 1984.
Baille, Franck. *Les petits maîtres d'Aix à la Belle Époque, 1870–1914*. Aix-en-Provence, 1981.
Bazzoli and Muntaner. *Les Provences de la peinture*. Marseilles, 1990.
Cabanne, Pierre. *Henri Manguin*. Neuchâtel, 1964.
Cazeau, Philippe. *M. Luce*. Paris, 1982.

D'Eze, Sylvie. *La Provence vue par les peintres*. Geneva, 1987.
Forneris, Jean. *Catalogue du musée des beaux-arts*. Nice, 1986.
Girard, Joseph. *Catalogue illustré du musée Calvet de la ville d'Avignon*. Avignon, 1924.
Hild, Eric. *Catalogue du musée de l'Annonciade*. Saint-Tropez, 1989.
Latour, Murielle and Jean Boissieu. *Marseille et les peintres*. Marseilles, 1990.

Monery, Jean-Paul. *Le musée de l'Annonciade, Saint-Tropez*. Paris, 1994.

WORKS IN ENGLISH
Brodskaya, Natalia. *The Fauves*. London, 1994.
Coutagne, Denis. *Cézanne in Provence*. New York, 1996.
Girard, Xavier. *Matisse in Nice 1917–1954*. New York, 1996.
Whitfield, Sarah. *Fauvism*. London, 1991.

Photo credits/copyright

Editorial direction: Catherine Laulhère-Vigneau
Assistant editor: Julie Rouart
Design: Caroline Chambeau/Studio Flammarion
Color separation: Sele Offset, Turin
Typesetting: Studio X-Act, Paris

Translated by Christine Schultz-Touge
Copy-editing: Laurel Hirsch

Originally published as *Les peintres de Provence* © Plume/Flammarion, 2000
English-language edition © Flammarion, 2000
Flammarion, 26, rue Racine, 75006 Paris, France

ISBN: 2-08013-686-0
N° FA3686-X-00
Dépôt légal: October 2000